Letter from the Publisher

Publisher and Creative Director:
B. Martin Pedersen

Chief Visionary Officer:
Patti Judd

Design Director:
Hee Ra Kim

Designers:
B. Martin Pedersen
Hee Ra Kim
Hiewon Sohn

Associate Editor:
Colleen Boyd

Publisher's Assistant /Designer:
Claire Yuan Zhuang

Writer:
Maxim Sorokopud

Interns:
Diamonte Maldonado
Jacqueline Salazar Romo

Japanese Advisors:
USA: Toshiaki & Kumiko Ide
Japan: Taku Satoh
Sakura Nomiyama

Chief Executive Officer:
B. Martin Pedersen

Cover Image:
Golden Headed Pheasant
Photo by Peter Samuels

Published by:
Graphis Inc.
389 5th Ave., Suite 1105
New York, NY 10016
Phone: 212-532-9387
www.graphis.com
help@graphis.com

ISBN 13: 978-1-954632-27-1

Dear Graphis Readers,

Welcome to Graphis Journal 381. As we celebrate Graphis' 80th year of championing the best in Design, Advertising, Photography, Art/Illustration, and Education, we proudly present this edition with exclusive and insightful Q&As with Graphis Masters and leading creative talents. These conversations not only unveil our featured individuals' creative processes and philosophies but also provide a deeper understanding of the innovations currently shaping the future of these vibrant fields. Each narrative and interview demonstrates the enduring power of creativity and our relentless pursuit of excellence, reflecting our rich heritage and ongoing commitment to the visual arts and communication. Join us on this celebratory journey as we continue to explore and document the pinnacles of creative achievement.

DESIGN: Graphis Master **Poulin + Morris Inc.** (US) exemplifies collaborative success in design, seamlessly integrating storytelling with visual communication. On the other side of the globe, **Masahiro Aoyagi** (JP) of **TOPPAN INC.** champions open-mindedness in personal and professional growth. In Canada, **Derwyn Goodall**'s (CA) approach at **Goodall Integrated Design** merges social consciousness with strategic beauty, crafting impactful visual narratives that resonate across various audiences.

ADVERTISING: At **Sukle Advertising** (US), **Mike Sukle** and his team are fueled by the drive to innovate within sectors like sustainability and health, demonstrating how creative advertising strategies can elevate brand identities and engage consumers on deeper levels.

PHOTOGRAPHY: This section highlights the work of two Graphis Masters. **Peter Samuels** (US) credits his transition from still life to animal portraiture to the adoption of his first dog, Leica, who inspired his current passion for capturing animals through his lens. Meanwhile, **Howard Schatz** (US) relentlessly explores new frontiers in photography, continually experimenting and evolving his techniques to perfect his art.

ART/ILLUSTRATION: Renowned for his evocative illustrations, Graphis Master **Guy Billout** (FR/US) has consistently captured the eye of audiences around the globe with his work featured across various high-profile platforms, earning accolades for his unique visual storytelling.

EDUCATION: **Douglas May** brings a wealth of real-world experience to the **University of North Texas**, nurturing the next generation of designers in aesthetics, innovative thought, and business acumen.

PRODUCTS:
Cars: The **Rolls-Royce Ghost** (UK) offers a bespoke luxury experience, while the **Fetch+ 4** (US) electric bike from **Trek** redefines urban mobility with its impressive cargo capacity.
Planes: Diamond Aircraft's **Twin-Engine DA62** (AT) combines luxury with cutting-edge technology, and **Pipistrel**'s **Taurus Electro** (SI) sets a new standard for sustainable aviation with its solar-powered capabilities.

ARCHITECTURE: The **Azabudai Hills** (JP/UK) project in Japan, a collaboration between **Mori Building Co.** and **Heatherwick Studio**, exemplifies urban harmony with nature. In contrast, **Alchemy Architects**'s **weebarnHouse** (US) in the United States reinterprets rural aesthetics through modern, sustainable methods.

Thank you for your continued engagement and passion for the world of visual design and creativity. Your support inspires us to bring even more exceptional stories to light.

Yours sincerely,

B. Martin Pedersen
Publisher & Creative Director

We extend our heartfelt thanks to the international contributors who have made it possible to publish a wide spectrum of the best work in Design, Advertising, Photography, and Art/Illustration. Anyone is welcome to submit their work to the portfolio and award competitions at www.graphis.com. Graphis is not liable or responsible for any copyright infringement on the part of any individual, company, or organization featured in Graphis Journal and will not become involved in copyright disputes or legal actions. Copyright © 2024 Graphis, Inc. All rights reserved. Jacket and book design copyright © 2024 by Graphis, Inc. No part of this journal may be reproduced, utilized, or transmitted in any form without written permission of the publisher.

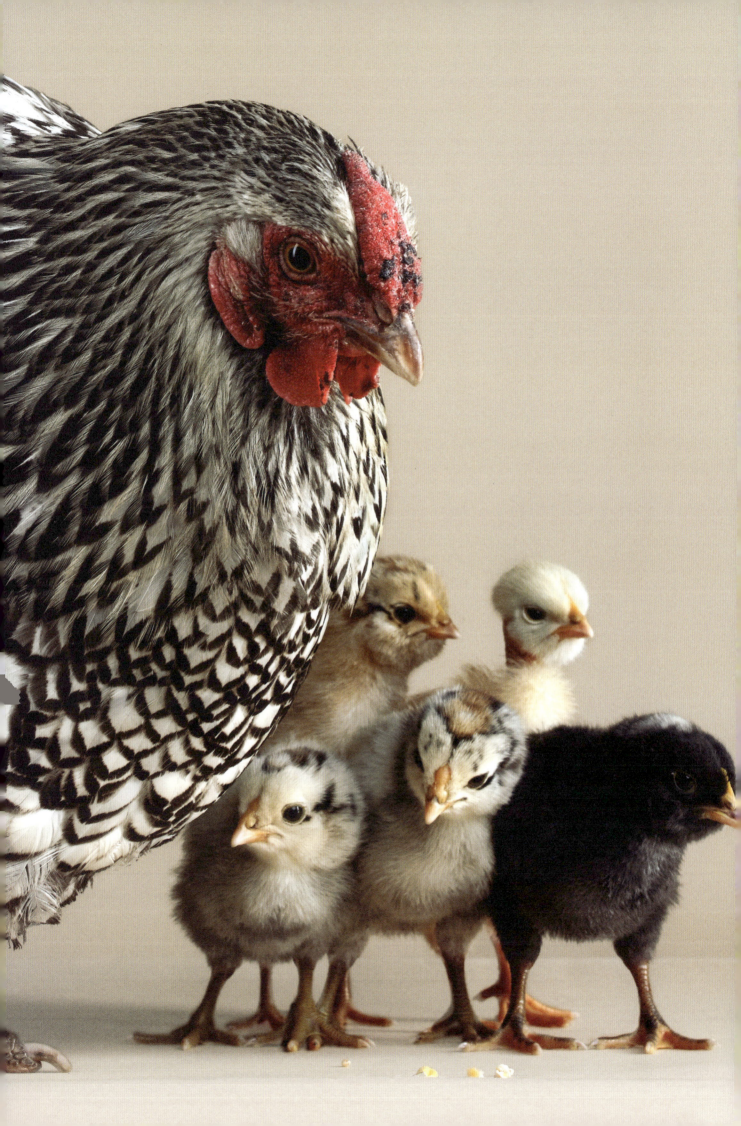

Contents

DESIGN:

10 Poulin + Morris Inc. / USA

Richard Poulin: Richard Poulin is a designer, educator, author, and artist living in Southern California. Throughout his career, he has focused on a generalist approach to all design aspects, including graphic, experiential, interior, and exhibition design, dividing his time between professional practice and academia. For over 30 years, he was the creative director and managing partner of Poulin + Morris Inc., which he co-founded in New York City in 1989. As a highly respected educator, he taught at Cooper Union and the School of Visual Arts for over two decades. He is a recipient of a research grant in design history from the Graham Foundation for Advanced Studies in the Fine Arts, a recipient of a Fellow from the Society of Experiential Graphic Design (SEGD), the profession's highest honor, and his work is in the permanent design collections of the Denver Museum of Art, the Letterform Archive, the Library of Congress, and the Los Angeles County Museum of Art (LACMA). Richard is also the author of several books on graphic design, typography, and design history, which have been translated into eight languages and used by students and practitioners worldwide. His new book, a comprehensive monograph on the life and work of mid-century modernist designer Rudolph de Harak—*Rational Simplicity: Rudolph de Harak: Graphic Designer*—was released in 2022 by Thames & Hudson (London). As an artist, his multi-media collage constructions have been exhibited throughout the United States and are in the collections of several private collectors. Richard lives in Palm Springs, California. You can follow his work or contact him on Instagram (@richardpoulin) or Richardpoulin.net.

Douglas Morris: As design director and partner of Poulin + Morris Inc., a multidisciplinary design consultancy he co-founded in New York City in 1989 with Richard Poulin, Doug Morris directed branding and experiential graphic design programs for an extensive list of clients. His expertise in alternative sign technologies supported information and wayfinding programs with state-of-the-art electronic information display systems, interactive media, and live-action transmission. His work has been published in periodicals and books worldwide and has received awards from American Corporate Identity, the American Institute of Architects (AIA), the American Institute of Graphic Arts (AIGA), Applied Arts, the Boston Art Directors Club, Global Corporate Identity, Graphic Design USA, Graphis, and the Society for Experiential Graphic Design (SEGD). He also coauthored *Wayfinding: Designing and Implementing Graphic Navigational Systems*, published by RotoVision. Doug is a recipient of a Fellow from the Society for Experiential Graphic Design (SEGD), the profession's highest honor, a past president and board member of the organization, and a former chairman of its annual international design awards program entitled Diversity in Design. Since relocating to Palm Springs, he has become a self-taught knitter, entrepreneur, and fiber arts teacher to non-profit organizations that support the health and well-being of the LGBTQ+ community in the Coachella Valley. His online business and website, The Perfect Purl (theperfectpurl.com), donates all of its profits and related materials, as well as free classes, to these local organizations.

Introduction by Karen Gorczyca

For more than 30 years, Karen Gorczyca has worked as a senior project manager for Design Communications, a widely recognized company with over 40 years of experience in managing, engineering, and building specialty architectural elements for high-profile projects worldwide, including signage and wayfinding systems, experiential design elements, and integrated tech. Being at the forefront of innovation, their solutions are driven by their clients' creativity and their workforce's dedication. Karen lives in Florida with her husband and rescue pugs, and enjoys oil painting in her free time.

24 Masahiro Aoyagi, TOPPAN INC. / Japan

Masahiro Aoyagi is an art director and graphic designer. Since 1998, he has worked in the creative department of TOPPAN INC. He has worked on the art direction of corporate calendars and various other tools related to corporate branding, specializing in value-added printing and expression in printed materials using special processing. He is a member of JAGDA. He has won various awards, including three Graphis Platinum Awards; Gold, Silver, and Photography Awards at the Gregor International Calendar Awards; Gold, Silver, and Bronze Awards from BtoB Advertising; the Benny Award at the Premier Print Awards; and the Prime Minister's Award at the All Japan Calendar Competition. He is also the winner of the All Japan Catalogue and Poster Competition.

Introduction by Yu Adachi

Yu Adachi has worked in the graphic arts sector since 1993. He began his career in prepress before moving to a digital printing company in San Francisco. In 2007, he joined the corporate communications department at artience Co., Ltd (formerly Toyo Ink SC Holdings Co., Ltd). He is in charge of planning and art direction for corporate calendars as well as other communication tools.

38 Derwyn Goodall / Canada

Derwyn Goodall is a Canadian graphic designer and educator living in Toronto. Professionally, he is an accredited creative director and designer (RGD) with 35 years of high-profile, award-winning design and 20 years of post-secondary teaching experience. His firm, Goodall Integrated Design, is a full-service, strategic branding and design studio. They embrace an ideas-driven design process, meaningful collaboration, and rigorous attention to craft. They specialize in branding, corporate identity programs, print, packaging, environmental design, signage, wayfinding, and interactive experiences in numerous categories: science and tech, finance, arts and culture, and government. Derwyn's job is to help clients tell the world who they are and why they're essential—why they matter—not just to their target audiences but to real people. He takes complicated ideas and makes them understandable. He then makes them memorable so they resonate.

(Opposite page) Wyandotte Chicken with Chicks, Storybook Animals Series. Photographer: Peter Samuels

Introduction by Andrej & Katerina Jenik
Jenik Art Consultants is a proud family business owned by Andrej and Katarina Jenik. Since launching in 1997, they've forged their reputation on the close, trusting relationships they've developed among dealers and collectors in Canada and worldwide. Over that time, they've operated successfully on a word-of-mouth basis; therefore, their clients speak for them best. Whether it's purchasing a single piece of artwork or developing an entire collection, they adopt a professional, personalized approach throughout, emphasizing exclusivity and discretion. Trust them to take care of all aspects of an acquisition, including any framing, restoration, shipping, and installation, while ensuring the entire experience is as enriching as the art itself.

ADVERTISING:
52 Sukle Advertising / USA
As a creatively led, independent agency, Sukle is obsessed with solving exciting problems. Their clients are the challengers attacking these complex problems and facing significant barriers, all while having oversized aspirations and a belief they can win. For almost 30 years, Sukle's award-winning creative solutions, driven by intelligent strategy grounded in audience insight and human truth, have delivered disproportionate results to accelerate global change. Never satisfied with the status quo, they push their creative strategy, brand development, advertising, and design to break the mold. Based in Denver, Sukle partners with future-minded brands in the sustainability, health, food and beverage, technology, financial, and outdoor industry spaces across the United States.

Introduction by Rosemary Dempsey
Since 2016, Rosemary Dempsey has been the communications director at Great Outdoors Colorado (GOCO), which has invested a portion of Colorado Lottery proceeds in the state's parks, trails, wildlife, rivers, and open spaces. Prior to this public sector role, she was a creative director and director of storytelling for a digital marketing firm in Denver. She received her master's degree from the University of Colorado at Boulder's Journalism School and her bachelor's from Dartmouth College. Rosemary aims to share stories of GOCO's inspiring work so that even more Coloradans realize the benefits of experiencing the great outdoors.

PHOTOGRAPHY:
66 Peter Samuels / USA
Before moving to San Francisco in 1999, Peter was classically trained as a product and still life photographer at Orange Coast College in Costa Mesa, California. His clients included notable names such as AT&T, Toyota, Nissan, and Visa. Then, in 2009, a change occurred when he got his first dog, a doxie/min pin mix named Leica, who soon became his muse, and a new passion emerged as he began to focus on photographing animals. Oddly enough, his technical experience in lighting products became the foundation of his approach to photographing animals, bringing about a production level that's become a cornerstone of his visual style. He says, "It's certainly more difficult to photograph a moving subject rather than a product, but the essential formula is the same and is the basis of how I use light in my work." And it seems to be working, as work and accolades are coming in like never before! "It's been very exciting!" he says. While his time with Leica was sadly cut short, she lovingly inspired a new direction in his career (good dog!). His clients now include animal brands and related work for Clorox's kitty litter, Nature's Recipe, Virgin America, Hush Puppies, the SPCA, Amazon, Zynga, and others. In addition to his commercial imagery, artwork sales have also become a growing part of his work.

Introduction by Kevin Raich
Kevin Raich, an award-winning global creative leader for iconic brands, believes in impacting the human experience as well as business outcomes through compelling, relatable stories. Using curiosity, heart, and visionary insight, his contributions played a meaningful role in Apple's prestigious Grand Prix win at Cannes for Today at Apple, Meta's launches of the metaverse and Meta AI, and Google's worldwide initiative for small businesses. Mr. Raich has worked with public figures, including Mark Zuckerberg, Tom Brady, Kendall Jenner, Morgan Freeman, and Snoop Dogg. He's written global taglines for The Ritz-Carlton, Uber, and Zillow. His work can be seen at kevinraich.com.

80 Howard Schatz / USA
Howard Schatz has received international acclaim for his work. He has published 23 books of his work, with his most recent, PAIRS, published in the fall of 2023. He has won virtually every award in photography, with over 200 museum and gallery exhibitions worldwide. Howard has made extraordinary images for Ralph Lauren, Escada, Sergio Tacchini, Nike, Reebok, Wolford, Etienne Aigner, Sony, Adidas, Finlandia Vodka, MGM Grand Hotel, Virgin Records, and Mercedes-Benz. Howard's fine artwork is represented in galleries in the United States and abroad. He posts the weekly "A PHOTOGRAPH" at www.howardschatz.com/blog.

Introduction by Ariel Orr Jordan
Ariel Orr Jordan's diverse careers include writing and directing over 27 TV docu-dramas. He co-conceived the global hit play *The Vagina Monologues* with Eve Ensler, and as a psychotherapist, for 14 years, he maintained a successful private practice in New York City. Across the US, Ariel created and facilitated the innovative and influential Healing Anger Workshop, which deals with childhood sexual abuse and trauma and helps adults struggling with intimate relationships and sexuality. Ariel co-wrote the art book *Bed as Autobiography* about the painter John Ransom Phillips, which was published by the University of Chicago Press. He co-wrote the book *The Fear of Love* with Marlisa Trombeta, and he also co-wrote and co-produced/directed the documentary *Beautiful Daughters* for Logo. Ariel has been interviewed and written about in some 30+ magazines and newspapers. He has appeared on Larry King Live, the Phil Donahue Show, the Geraldo Rivera Show, CBS Nightly News, National Public Radio, and over 25 other television programs. As a visual artist, Ariel curetted and exhibited the pioneering group art show "The Guilty Victim" in NYC. The exhibition was reviewed and written about in *The New York Times*, *Daily News*, *Newsday*, and many other newspapers and magazines. Since then, he has had more than 20 one-man and group shows nationwide.

(Opposite page) Man cleaning under the Pisa Tower for a story about Italy having to clean up her act to meet the Maastricht's standards. Time magazine UK, about 1990. Art Director: Paul Lussier. Illustrator: Guy Billout.

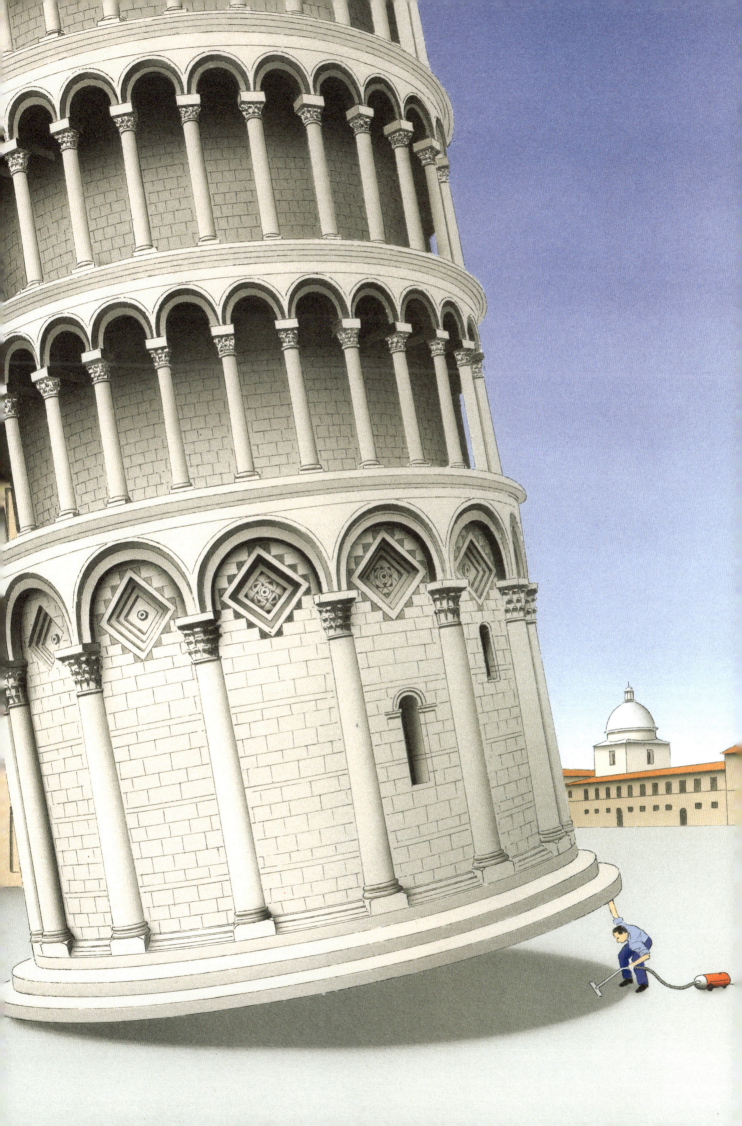

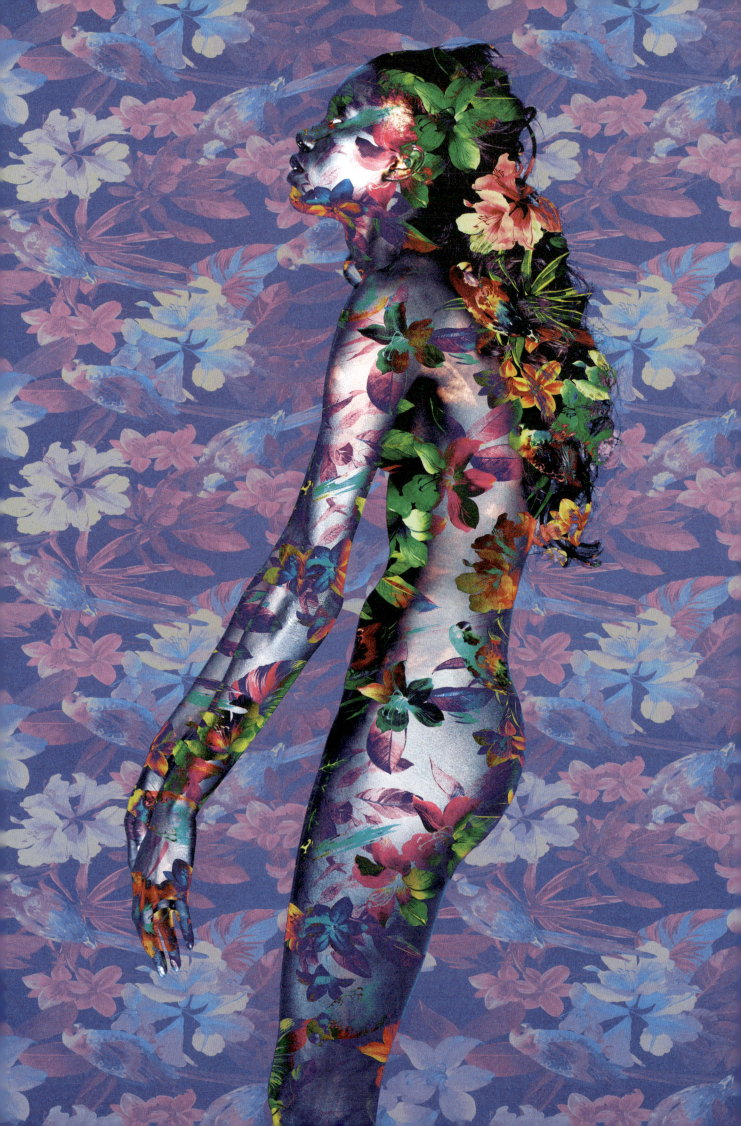

ART/ILLUSTRATION:

96 Guy Billout / France & USA
Born and educated in France, Guy Billout was a graphic designer for ad agencies in Paris before moving to New York in 1969 to become an illustrator for magazines, newspapers, corporate brochures, and ad campaigns. He is the author and illustrator of nine children's books, five of which were selected by *The New York Times* as the 10 Best Illustrated Children's Books in subsequent years. He has taught at Parsons School of Design in New York since 1987. Guy was inducted into the New York Society of Illustrators' Hall of Fame in 2015.

Introduction by Timothy Cain
Timothy Cain is a creative director, adventurer, entrepreneur, storyteller, and student of life. His mission is to open eyes to the "why" behind the "what," connect the dots, connect people, and reintroduce the mind to the heart. He's been published by DK/London and has launched new labels, books, and marketing for the National Geographic Society, the Smithsonian, and Simon & Schuster, as well as Fortune 500 brands ranging from beauty and finance to sports and automotive. He's designed, redesigned, and launched major magazines in the US and abroad. His work has been featured in the Society of Publication Designers and *Print* magazine and has received various awards.

PRODUCT:

112 Ghost by Rolls-Royce / UK *Written by Maxim Sorokopud*
Since 1906, Rolls-Royce has been synonymous with the highest quality in motoring. Its commitment to innovation shines through with the latest iteration of the highly successful Ghost automobile, which has been almost entirely redesigned.

114 Fetch+ 4 by Trek / USA *Written by Maxim Sorokopud*
In 1976, after running bicycle stores in Wisconsin, Dick Burke and Bevil Hogg founded Trek in a rural barn to build bikes of extraordinary artistry. Today, the company is headquartered just one mile away from this barn and headed by Dick Burke's son, John. The Fetch+ 4 proves that Trek has challenged the limits of bicycle capabilities.

116 Twin-Engine DA62 by Diamond Aircraft / Austria *Written by Maxim Sorokopud*
Over 5,500 Diamond airplanes are currently in operation across the globe, ranging from two-seat single-engine to seven-seat twin-engine vehicles. Since 1981, its planes have been pioneering the aviation industry, winning numerous awards in the process.

118 Taurus Electro by Pipistrel / Slovenia *Written by Maxim Sorokopud*
For over 30 years, Pipistrel has been manufacturing aircraft, expanding from simple hang gliders in Slovenia to a range of airplanes across the world. The Taurus Electro continues its mission of finding new aviation solutions.

ARCHITECTURE:

122 Azabudai Hills by Mori Building Co. & Heatherwick Studio / Japan & UK *Written by Maxim Sorokopud*
Thomas Heatherwick founded Heatherwick Studio, implementing a design process that encourages every team member to both challenge and contribute ideas. Azabudai Hills is the first district that the studio has created in Japan, overseeing the public realm areas and lower podium-level architecture.

124 weebarnHouse by Alchemy Architects / USA *Written by Maxim Sorokopud*
Geoffrey C. Warner founded Alchemy Architects in 1992. Since 2003, it has installed dozens of weeHouses and barnHouses across the USA.

EDUCATION:

128 Douglas May (University of North Texas) / USA *Portrait by Jim Olvera*
Douglas May is an Associate Professor at the University of North Texas College of Visual Arts and Design. His academic research focuses on defining communication design as an interfacing domain enabled through transcoding, i.e., converting language or information from one form of coded representation to another to allow ease of understanding. Educated at the University of North Texas and the ArtCenter College of Design, he began his career working for several prominent designers and art directors in New York. He founded the Dallas-based design firm May&Co. in 1986 and continues to consult with corporations, entrepreneurs, and non-profits by providing design communication to support strategic initiatives. His professional practice has included a range of assignments from international to local clientele. He received his MFA from Texas A&M-Commerce in 2017 and now teaches full-time at the University of North Texas, achieving academic tenure in 2023. The 2023 Golden Egg Lifetime Achievement Award from the Dallas Society of Visual Communications tops his professional recognition, design awards, and multiple career achievements, including becoming an AIGA Fellow recipient in 2011 and receiving the AAF Dallas 2020 Educator of the Year Award. His posters have been exhibited internationally by invitation in design exhibits in South Korea, England, Poland, Switzerland, and Indonesia.

Introduction by Ashley Owen
Ashley Owen is a Dallas-based experience designer at PwC. Her team works with global users to create internal and external-facing products, and she focuses primarily on designing tax and climate sustainability platforms at the firm. She graduated from UNT in 2022 with a BFA in communication design with a concentration in graphic design and minors in art history and journalism. She was a student of Douglas May for three years.

141 Graphis Books: Recent Titles
142 Graphis Journal: Recent Issues
144 Graphis Advisory Board Member Biographies

(Opposite page) Beauty Study #1460: Sigail Currie. Photograper: Howard Schatz

DESIGN

10 POULIN + MORRIS INC. / USA

24 TOPPAN INC. / JAPAN

38 DERWYN GOODALL / CANADA

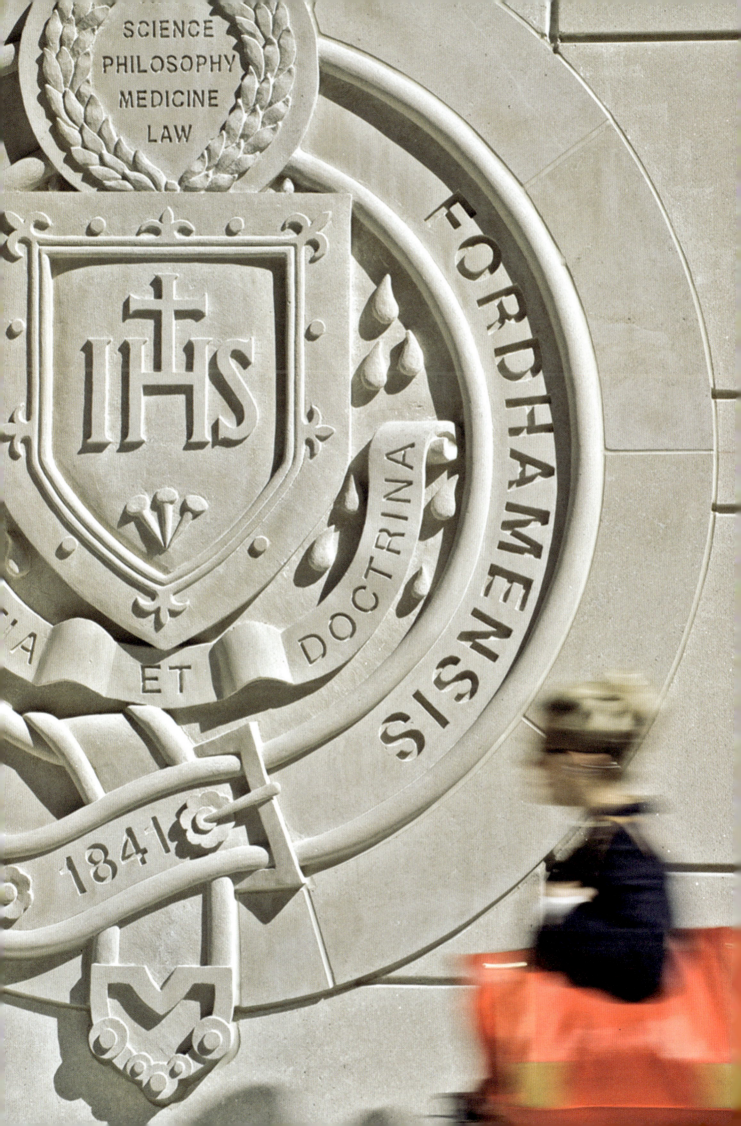

Poulin + Morris: Design is A State of Mind

THE COLLECTIVE WORK OF POULIN + MORRIS REPRESENTS A SPECIAL PLACE OF EXCELLENCE AMONG THOSE CONTEMPORARY PRACTICING GRAPHIC DESIGNERS WHO HAVE MAGNIFICENTLY EXTENDED THE VALUES OF MODERNISM.

THEIR ACCOMPLISHMENTS, VIEWED AS A WHOLE, EXEMPLIFY CONSISTENT MASTERY OF THE FORMAL ELEMENTS OF GRAPHIC DESIGN IN THE SERVICE OF SOLVING CLIENTS' PROBLEMS.

R. Roger Remington, *Professor Emeritus, Rochester Institute of Technology*

RICHARD POULIN AND DOUGLAS MORRIS ARE A PERFECT COMBINATION OF DESIGNERS. THEIR MAGIC LIES IN A LOVE OF PROCESS, A SHARED VISION, AND A LOVE OF EACH OTHER.

Richard Wilde, *Chair Emeritus, BFA Advertising & BFA Design, School of Visual Arts*

AS A FORMER PARTNER OF DE HARAK, RICHARD CREATED A PUBLICATION THAT COMBINED IN-DEPTH PERSONAL AND DESIGN KNOWLEDGE WITH A GREAT ATTENTION TO DETAIL TO ENSURE THE BOOK IS AND WILL REMAIN THE DEFINITIVE WORK ON THE SUBJECT.

Lucas Dietrich, *Director of Publishing & Digital, Thames & Hudson (London)*

THEY DO NOT DISCRIMINATE BY SELECTING THEIR PROJECTS BASED ON CLASSIFICATION. THEY APPROACH DESIGN UNIVERSALLY AND OPTIMISTICALLY AS A SHIFT IN SCALE, CONTEXT, AND MATERIALITY, EXERCISING THOUGHTFUL RESTRAINT.

Josh Owen, *Professor & Director of the Vignelli Center for Design Studies, Rochester Institute of Technology*

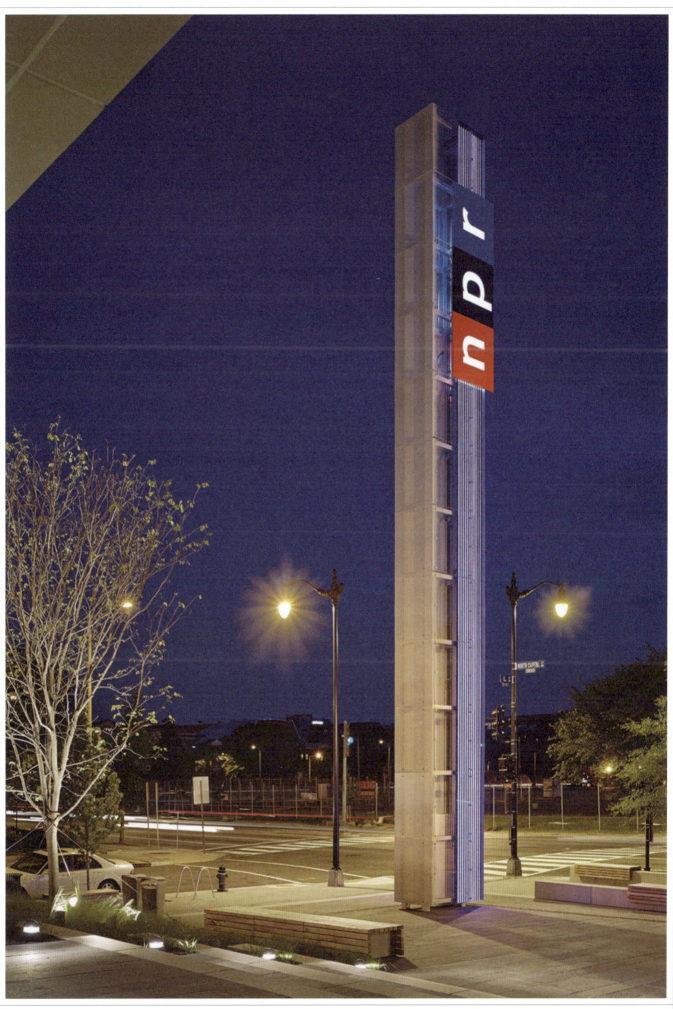

*(Page 9) Fordham School of Law at Lincoln Center, New York, NY. Environmental Graphics, Wayfinding, and Donor Recognition Programs.
Architect: Pei Cobb Freed & Partners. Client: Fordham University
(Above) NPR Headquarters and Production Studios, Washington, DC. Environmental Graphics, Wayfinding, Visitor's Experience, Donor Recognition Programs,
and Exhibition Design Program. Architect: Hickok Cole Architects. Client: NPR*

Introduction by Karen Gorczyca *Senior Project Manager, Design Communications Ltd*

My professional relationship with Richard and Doug began nearly three decades ago as a project manager for DCL. My job was to bring their design concepts to tangible, built results for contemporary landmarks nationwide. With a strong understanding of materials and a near obsession with details and the integrity of the design, Richard and Doug always had an unwavering, clear vision for the direction of their work. They also had no fear of pushing the limits of possibilities. This was often a challenge, but meeting that challenge was what made our collaborations so rewarding and led to our professional relationship growing into a warm friendship as well. Their passion for the details and the crisp, clean elegance of the final result is evidenced in their entire body of work.

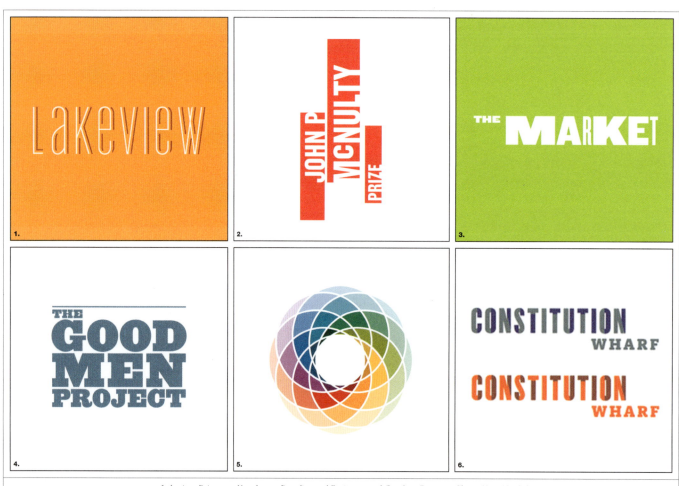

1. *Lakeview. Princeton, New Jersey. Branding and Environmental Graphics Program. Client: Novo Nordisk*
2. *John P. McNulty Prize. New York, New York. Branding Program. Client: The McNulty Foundation*
3. *The Market. Princeton, New Jersey. Branding and Environmental Graphics Program. Client: Novo Nordisk*
4. *The Good Men Project. Boston, Massachusetts. Branding and Publication Design. Client: The Good Men Foundation*
5. *Dubai Waterfront. Dubai, United Arab Emirates. Branding Program. Client: FXFOWLE Architects*
6. *Constitution Wharf. Boston, Massachusetts. Branding, Environmental Graphics, and Wayfinding Sign Program. Architect: Perkins&Will. Client: National Development*
(Opposite page) The Franklin Institute. Philadelphia, Pennsylvania. Donor Recognition Program. Architect: SaylorGregg Architects. Client: The Franklin Institute

DOUG AND I ALWAYS PUSHED OUR OWN BOUNDARIES OF CREATIVITY AND VISUAL EXPRESSION TO NEW HEIGHTS AND FORMS OF MEANING IN OUR WORK.

Richard Poulin, *Co-founder, Poulin + Morris Inc.*

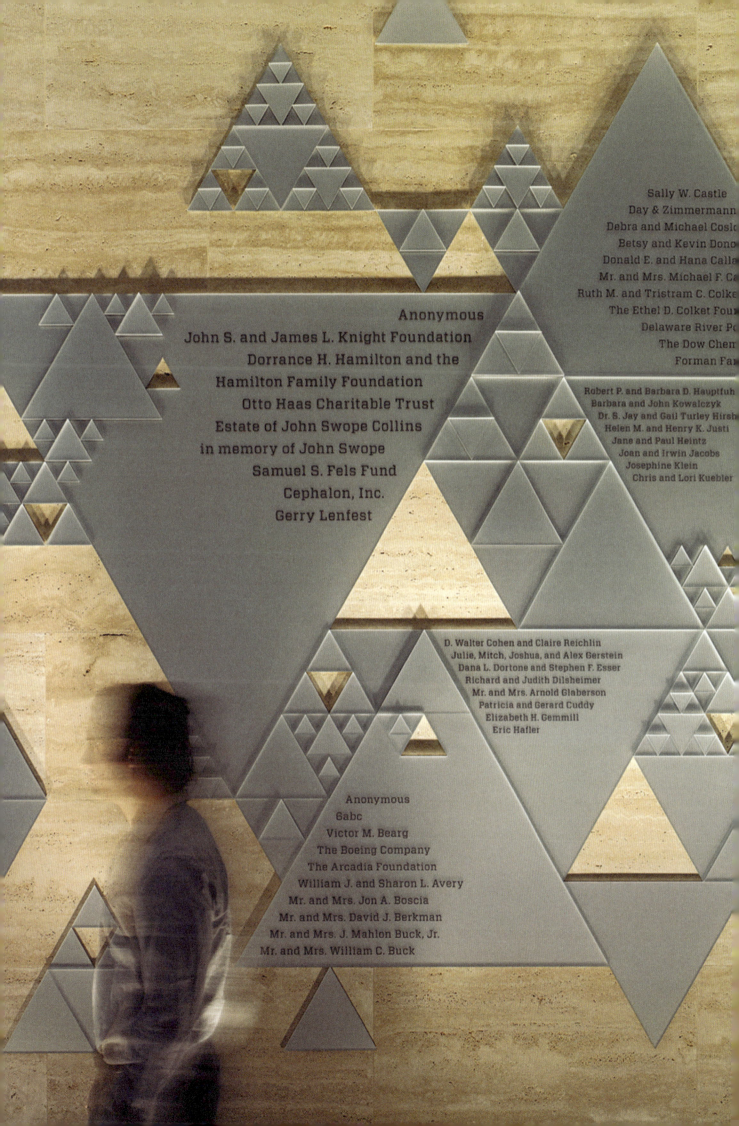

Q&A: Richard Poulin & Douglas Morris, Co-founders, Poulin + Morris Inc.

What has inspired or motivated you in your career?
Growing up in New York City gave us the opportunity to constantly explore and experience new things that we had never imagined before. It changed our lives in terms of the visual world, and it has been a tremendous inspiration to us. We also never thought that we would have such an impact on the visual fabric of the city. Much of our work is an integral part of the city's visual landscape, and hopefully, it will be there for years and years to come. It's wonderful to be a part of that, and we are very proud of that fact.

What is your work philosophy?
When asked this question, we have always responded with the words of Eric Gill (1882–1940) that fully defines our work philosophy: "What is a work of art? A word made flesh... a thing seen, a thing known, the immeasurable translated into terms of the measurable." We believe that the most important aspect of these words is the goal of creating something new all the time, and hopefully, it's something that is memorable and measurable but, at the same time, unforgettable and immeasurable.

What is it about design that you are most passionate about?
We have always believed that we need not limit ourselves to only the printed page. Design has provided us the insight and creative freedom to practice and move from one discipline to another with ease and confidence.

Who have some of your greatest past influences been?
Paul Rand, Saul Bass, Massimo Vignelli, Will Burtin, Charles and Ray Eames, Deborah Sussman, and Rudolph de Harak.

Who have been some of your favorite colleagues or clients?
Doug and I agree that we never had favorites. However, some of our longtime clients, such as James Stewart Polshek (FAIA of Ennead Architects), Kohn Pedersen Fox Architects, NPR, Hines, and Time Warner stand out because they continuously trusted us to solve the numerous design problems they approached us with over the years. They were true colleagues and collaborators and were always open to new ideas and approaches to a design problem.

What are the top things you need from a client in order to do successful work for them?
Freedom, trust, and honest communication.

What about your work gives you the greatest satisfaction?
What we did collectively and individually with the development, growth, and evolution of our work and office over a period of 30 years is something that we're very proud of; it was a tremendous part of our lives, and it was incredibly joyful and fulfilling.

What part of your work do you find the most demanding?
Every aspect of our lives is demanding. We wouldn't want it any other way!

What professional goals do you still have for yourself?
We have always pursued the multidisciplinary aspects of design and never wanted to limit ourselves to doing one type of work or, for that matter, working for one type of client. These have always been and continue to be our goals in work and in life.

What advice do you have for students starting out today?
Continue to push your own boundaries of creativity and visual expression to new heights and forms of meaning in your work. And remember, all great ideas and all significant works of art and architecture come from dreamers, visionaries, and communicators.

What do you value most in life?
Our freedom and creativity to think, live, and be who we want to be.

What would you change if you had to do it all over again?
Not one thing!

Where do you find inspiration?
We truly believe inspiration is everywhere. It envelops you. It's everything that you see and feel; that's why the things that we place around us and the things that we are drawn to are tremendous assets. New York City itself has always been an incredible, inspirational laboratory for us—its architecture and landscape, its pace, rhythm, and sounds, and the interactivity of its people. All of those things and more have been a tremendous catalyst for us in terms of the way we think about creativity and the way we evolve in our own creativity... What we tried to do in every project (whether it's architectural in nature, print in nature, or digital in nature) is to make as many connections as we could—informationally, thematically, aesthetically—and the more connections we made (if you can try to visualize a piece of fabric), the stronger those ties and those connections are; it will last longer, it will have more resonance, and it will maintain its relevance, and that's what we always try to do.

How do you define success, and where do you see yourself in the future?
Our lives as designers are organic; our thinking and perception of it is always evolving. Therefore, our definition of success, as well as our vision of our own future, is always changing.

How do you balance your work with your personal life if there is a distinction between the two for you?
Fortunately for both of us, there has never been a distinction between our professional and personal lives. We believe design is a state of mind, a way of seeing, and most importantly—a way of living.

Poulin + Morris Inc. www.poulinmorris.com
See their Graphis Master Portfolio at graphis.com.

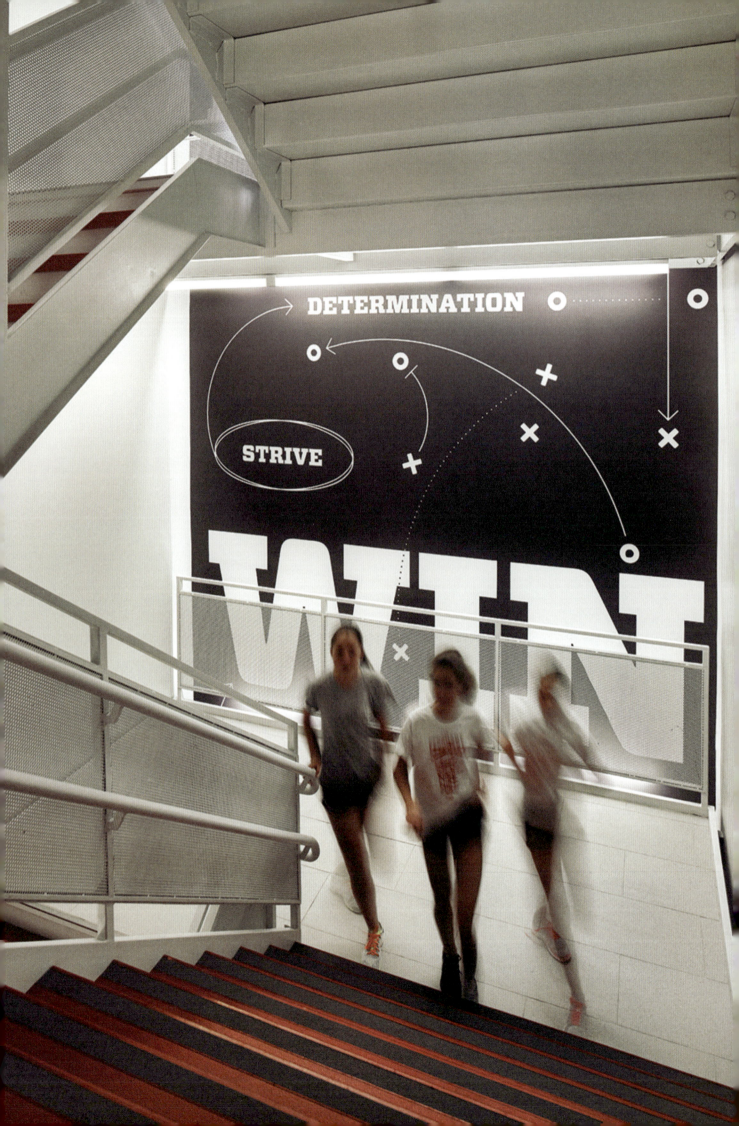

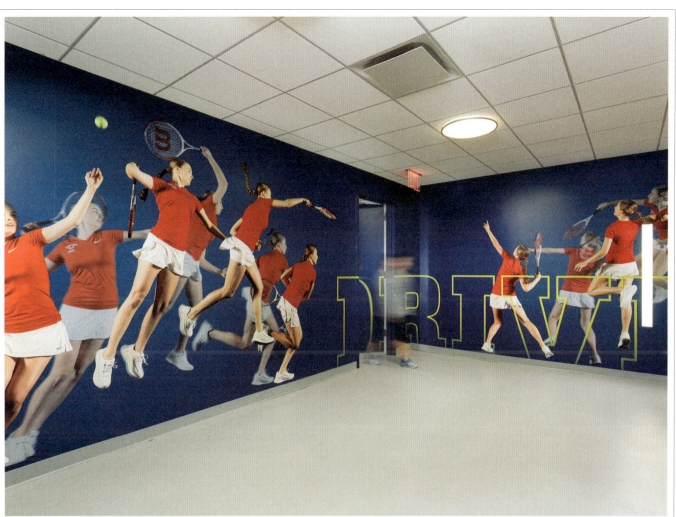

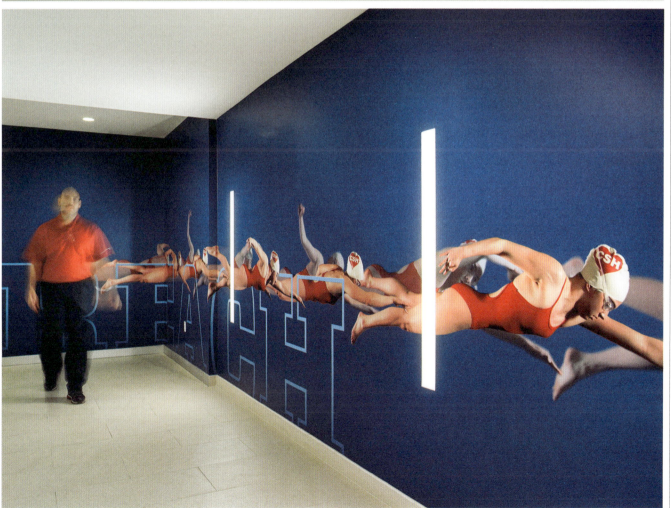

Convent of the Sacred Heart Athletic and Wellness Center. New York, New York. Environmental Graphics, Wayfinding, and Donor Recognition Programs. Architect: BKSK Architects. Client: Convent of the Sacred Heart

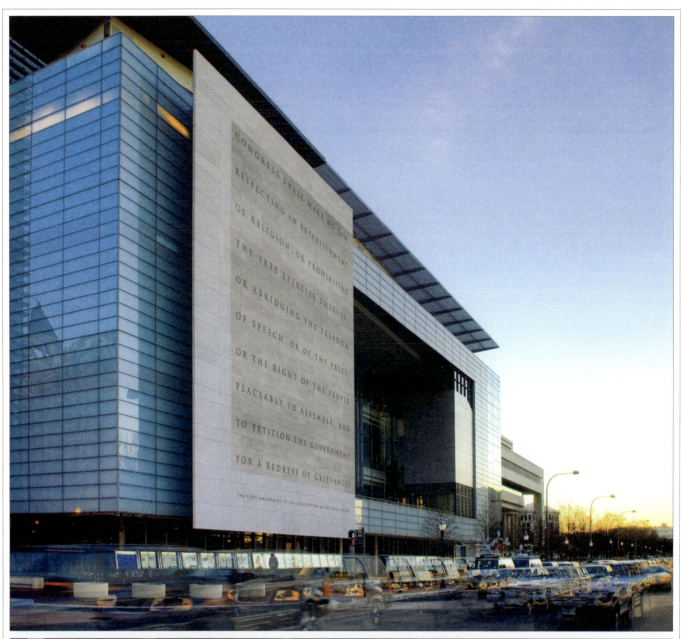

Newseum. Washington, DC. Branding, Environmental Graphics, Wayfinding, and Donor Recognition Programs. Architect: Ennead Architects. Client: Newseum/Freedom Forum

Newseum. Washington, DC. Branding, Environmental Graphics, Wayfinding, and Donor Recognition Programs. Architect: Ennead Architects. Client: Newseum/Freedom Forum

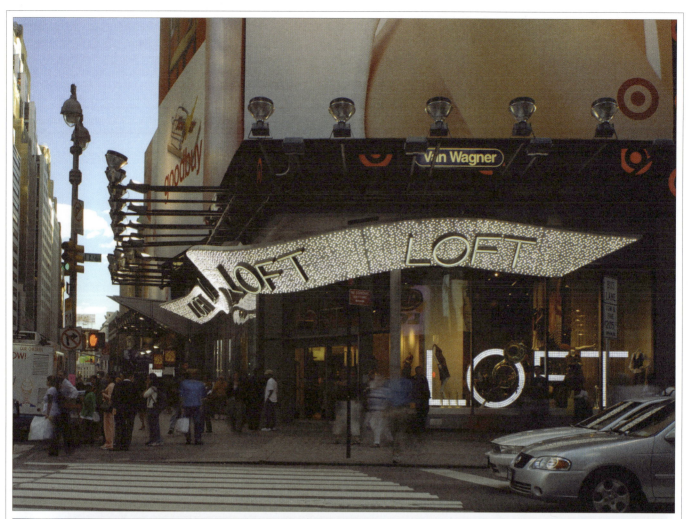

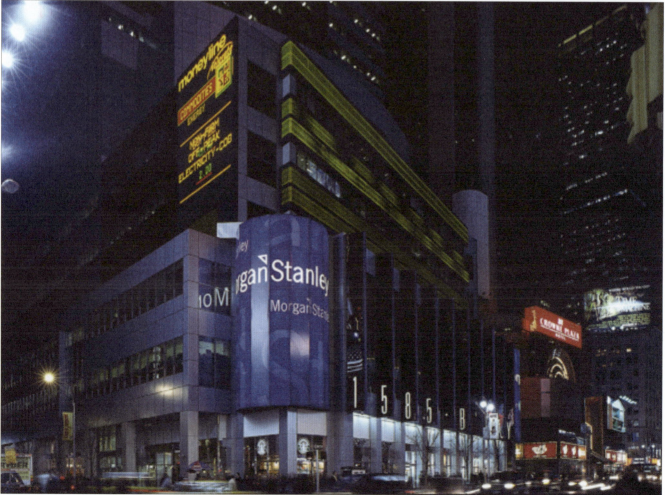

(Top) Ann Taylor Loft Times Square. New York, New York. Environmental Graphics Program. Architect: NBBJ. Client: Ann Taylor
(Bottom) Morgan Stanley World Headquarters. New York, New York. Environmental Graphics Program. Architect: Gwathmey Siegel and Associates. Client: Morgan Stanley
(Opposite page) Brooklyn Botanic Garden. Brooklyn, New York. Environmental Graphics Program. Architect: Ennead Architects. Client: Brooklyn Botanic Garden

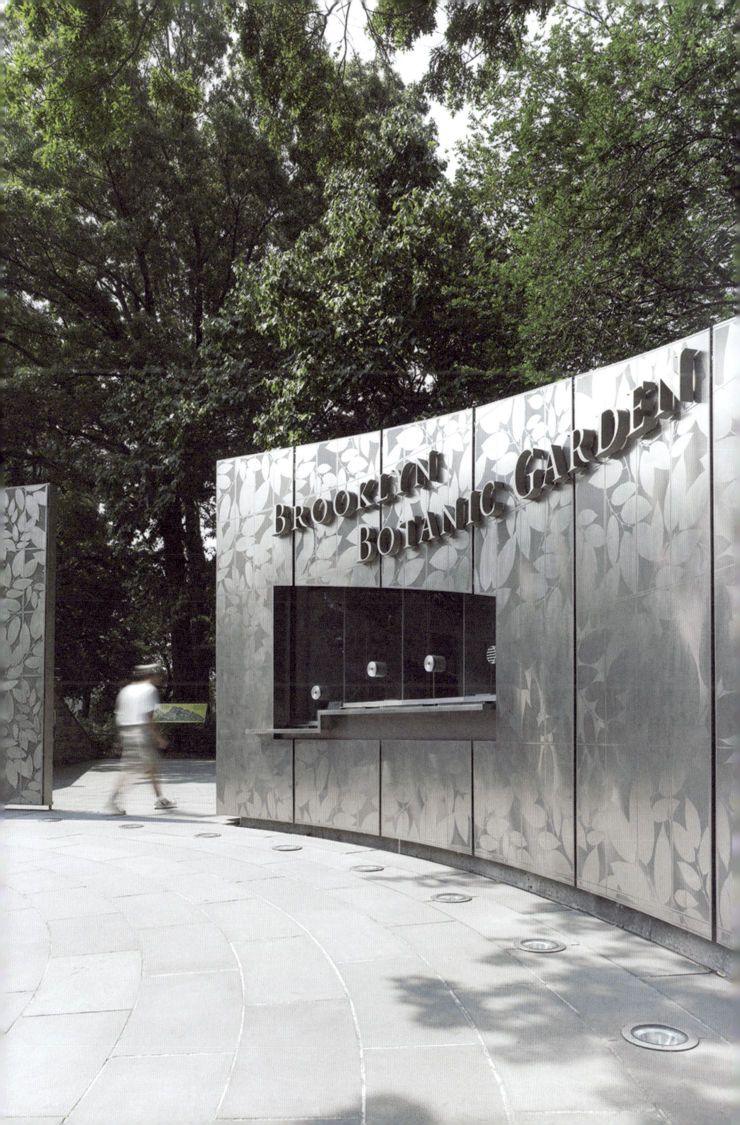

TOPPAN INC.: Providing Accurate Answers

HE PRESENTS A CLEAR VISION AND LEADS THE PRODUCTION TEAM WELL. HIS DEEP KNOWLEDGE OF ART, HIS EXPERIENCE IN PRINTING TECHNOLOGY, AND HIS CREATIVE IDEAS RESULT IN DESIGNS THAT GO BEYOND THE SCOPE OF FLAT GRAPHICS.
Fuyuki Hashizume, *Graphic Designer, TOR Design*

THE APPEAL OF HIS WORK LIES IN HIS ABILITY TO FIND THE BEST COMBINATION OF PRINTING, PAPER, AND PROCESSING BASED ON HIS DEEP KNOWLEDGE OF THE POWER OF PRINTING.

AS A SPECIALIST WITH A THOROUGH UNDERSTANDING OF THE CHARACTERISTICS AND APPEAL OF CALENDARS, HE HAS CREATED A UNIQUE WORLD THAT IS UNRIVALED.
Kohei Sakamoto, *Art Director, Bridgestone Corporation*

HE HAS ALWAYS HAD A LOVE OF PRINTING AND AN ENDLESS SPIRIT OF INQUIRY. AS AN ART DIRECTOR AND DESIGNER, HE HAS A TALENT FOR CREATING FORMS, BUT IT IS HIS DEEP ADMIRATION FOR PRINTING THAT IS THE SOURCE OF HIS TALENT.

SEEING MY DESIGNS TRANSFORMED BY HIS SKILLFUL PRINTING IS A MOVING ENCOUNTER.
Maho Shimada, *Art Director, TOPPAN INC.*

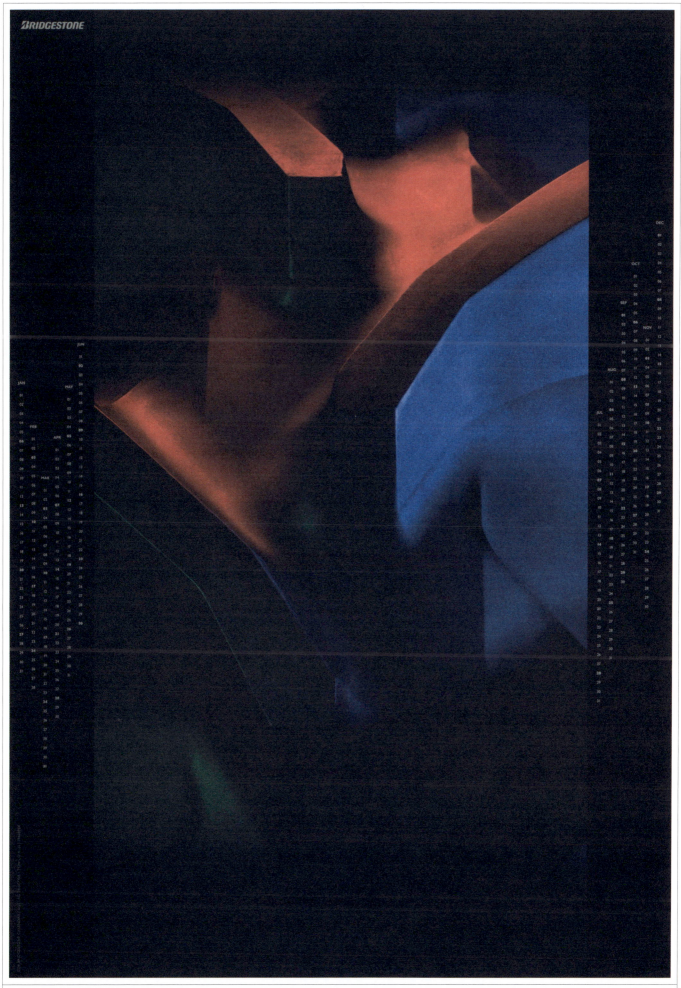

2019 BRIDGESTONE CALENDAR. Photographs by Tomohiro Ichikawa [TOPPAN INC.]

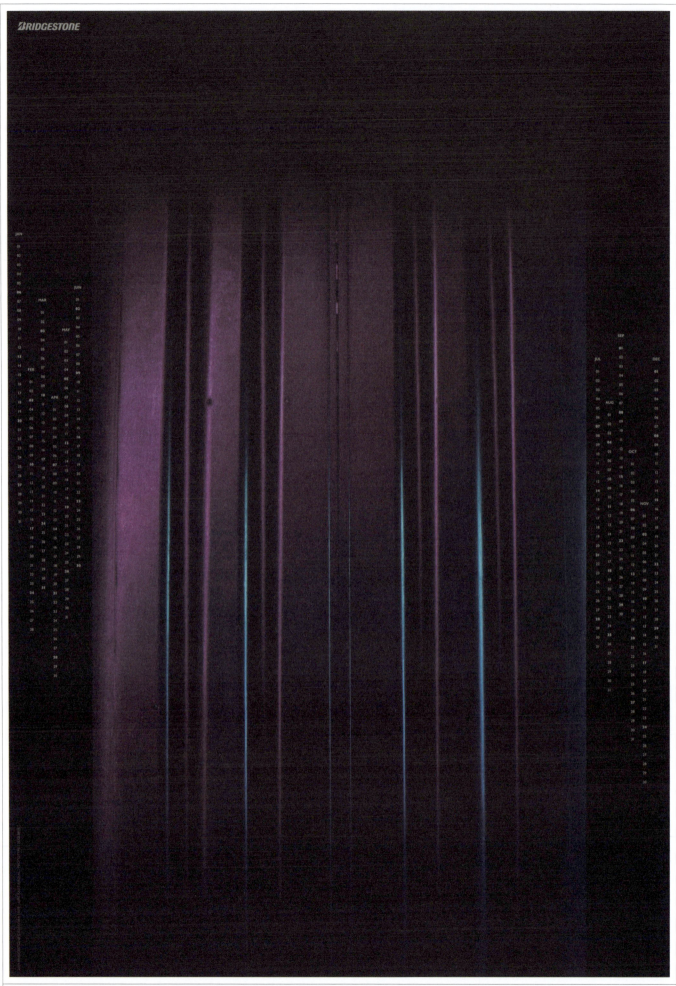

2019 BRIDGESTONE CALENDAR. Photographs by Tomohiro Ichikawa [TOPPAN INC.]

Introduction by Yu Adachi *Art Director, Corporate Communication Dept., artience Co., Ltd*

Mr. Aoyagi has been involved in the art direction of our calendars for 18 years since 2007, and he has been well-received by our customers. We have also hired him as an art director for various publications, greeting cards, and exhibition visuals. He not only has a deep knowledge of different kinds of art, such as illustration and photography, but also of printing techniques and materials, such as plate making, ink, and paper. He comes up with many ideas when choosing motifs, and he produces calendars with different tastes each year, which customers have received well. He understands our intentions, which tend to be vague, and reflects them in the production concretely to ensure smooth progress.

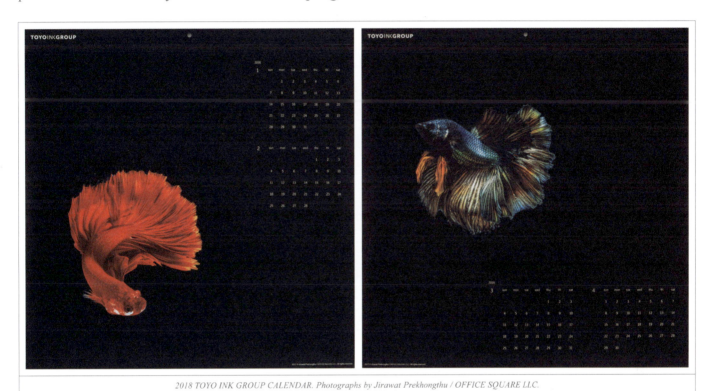

2018 TOYO INK GROUP CALENDAR. Photographs by Jirawat Prekhongthu / OFFICE SQUARE LLC.

WITH THE OBJECTIVE OF COLLABORATION IN MIND, I TRY TO WORK WITH RESPECT FOR EVERYONE INVOLVED IN THE PROJECT.

Masahiro Aoyagi, *Art Director & Creative Director, TOPPAN INC.*

Q&A: Masahiro Aoyagi, Art Director & Creative Director, TOPPAN INC.

What has inspired or motivated you in your career?
As a university student, I enrolled in a design course. I was particularly interested in graphic design, such as posters, etc. I wanted to be exposed to more graphic design, which led me to my current position as an art director.

What is your work philosophy?
Do not make judgments based on imagination alone. For example, if I come up with several directions for a layout, I don't make decisions in my head but always check them on a display or output before making a choice. No matter how simple the choice is, I always want to make a decision using my visual sense.

What is it about design that you are the most passionate about?
My tastes change depending on the time of the year, but right now, I'm conscious of keeping things as simple as possible and how to express my personality.

Who is or was your greatest mentor?
Although neither didn't directly mentor me, I would have to say the graphic designers Mitsuo Katsui and Masayoshi Nakajo. There was a time when I was exposed to their approaches to design, their many great achievements, and their personalities. This gave me a chance to rethink my own way of being.

Who were some of your most significant past influences?
The musician Trent Reznor of Nine Inch Nails. I started designing professionally in the 90s when MTV was in full swing. Music was one of my hobbies, and I was attracted to artists who expressed themselves visually, audibly, and even experientially. His works influenced me, including his diverse musicality and commitment to artwork with different approaches to them. I especially admire his attention to graphic art. Even now, when I'm in the middle of something or when I'm stuck, I listen to NIN while I work on it.

Who among your contemporaries today do you most admire?
It's hard to name a specific person. There was envy and admiration in the past, but now, my primary goal is to see what I can create by crossing myself with others. With the objective of collaboration in mind, I try to work with respect for everyone involved in the project.

Can you tell us a little about TOPPAN Printing Co., Ltd?
TOPPAN Printing Co., Ltd is a comprehensive printing company in Japan that handles a wide range of commercial products. We recently changed our company name from TOPPAN Printing, partly to take advantage of the various technologies we have cultivated as a printing company and partly because we are involved in a wide range of fields other than printing.

Was there a project that impacted your growth as a company or as an individual?
There is a project called "Graphic Trial" that TOPPAN is working on, and participating in it was the catalyst for me to get serious about printing.

What are the most important ingredients you require from a client to do successful work?
The most important element of a successful job is to not only provide an accurate answer to what the customer is looking for but also to present a different way of thinking to approach the problem and to exceed their expectations.

Who have been some of your favorite people or clients you have worked with?
There are several people. As many of our clients have been with us for a relatively long time, we have built good relationships with them. And my personal preferences became very close. The image of the destination becomes clear from the beginning, and I can focus on improving the quality without spending time on image matching.

What part of your work do you find most demanding?
If I consider the calendar only as a tool, unlike other sales tools, there is no clear answer to this question, which I think is the hardest part. For example, there is no visible result, such as, "The product will sell because it is a good package."

What professional goals do you still have for yourself?
With the evolution of technology, I believe that the boundary between professional and amateur forms of photography, painting, and design no longer exists. However, I think there is still a realm of professionals regarding printing. My goal is to update the expressions and ideas that professionals can only do in accordance with the times.

What do you wish you knew about the industry when you first started? What advice do you have for students starting out today?
I think it's important not to close yourself off from your own potential, as has been said for a long time. Although likes and dislikes are a part of our personality, there is nothing like a wide range of knowledge that provides us with food for thought.

What interests do you have outside of your work?
Music is a big part of my life, including my work. This has never changed, and I don't think it will change in the future, but my most recent interest is in outdoor activities, such as camping and fishing.

What do you value most?
To be satisfied with myself.

Where do you seek inspiration?
As mentioned, the strongest inspiration comes from music.

How do you define success?
Success is satisfying not only myself but everyone involved. That doesn't mean trying to please everyone but rather creating something that is unique yet aims to satisfy everyone, which is probably impossible to achieve.

Where do you see yourself in the future?
I hope to be in a position where I can convey to the world, even if only a little, the appeal of "printing" and "printed matter," which is becoming old technology.

TOPPAN INC. www.toppan.com

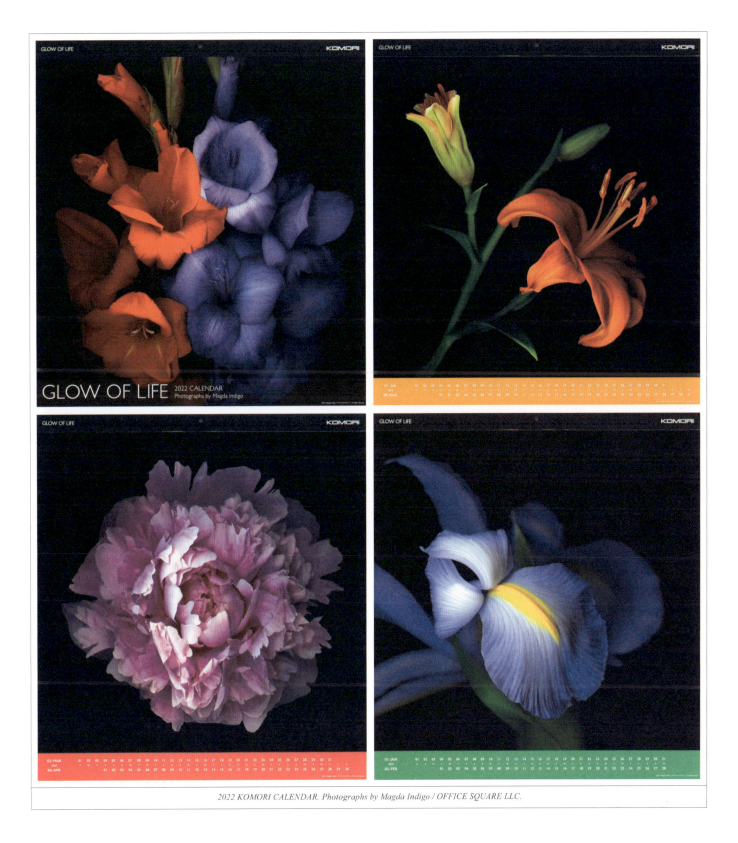

2022 KOMORI CALENDAR. Photographs by Magda Indigo / OFFICE SQUARE LLC.

I THINK IT'S IMPORTANT NOT TO CLOSE YOURSELF OFF FROM YOUR OWN POTENTIAL.

Masahiro Aoyagi, *Art Director & Creative Director, TOPPAN INC.*

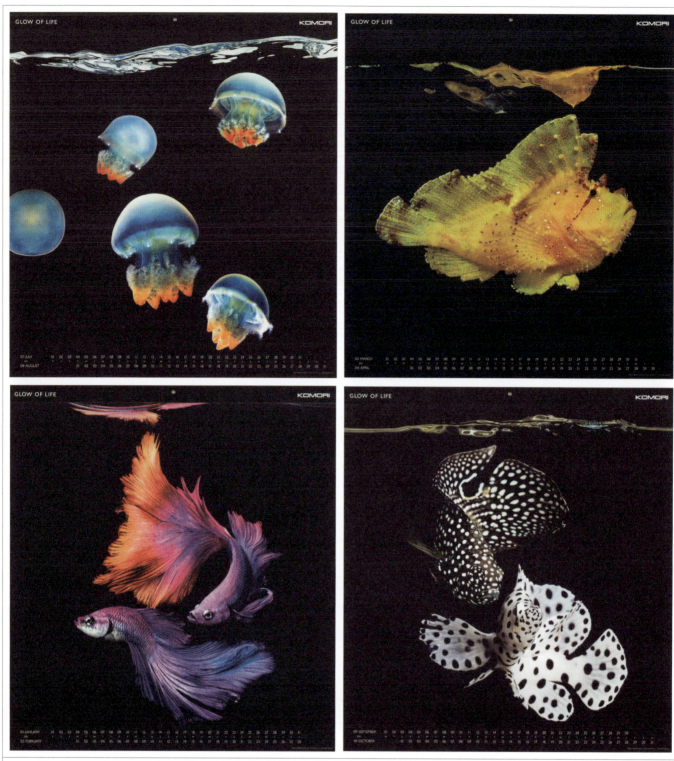

2021 KOMORI CALENDAR. Photographs by Mark Laita / OFFICE SQUARE LLC.

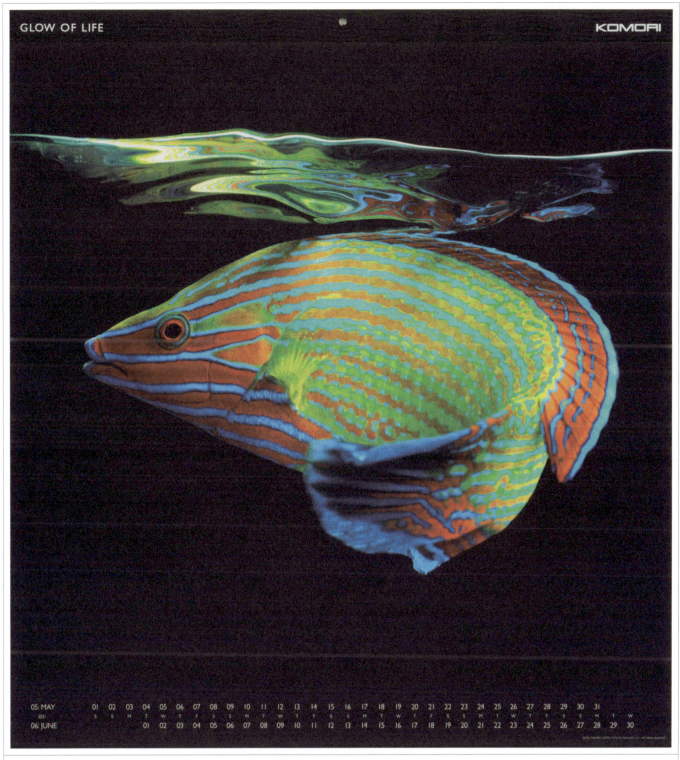

2021 KOMORI CALENDAR. Photographs by Mark Laita / OFFICE SQUARE LLC.

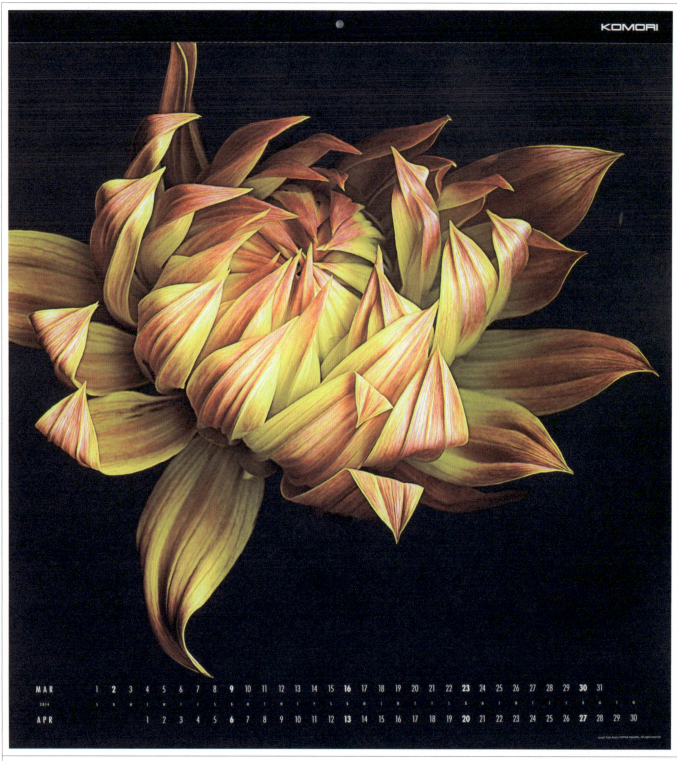

2014 KOMORI CALENDAR. Photographs by Kate Scott / OFFICE SQUARE LLC.

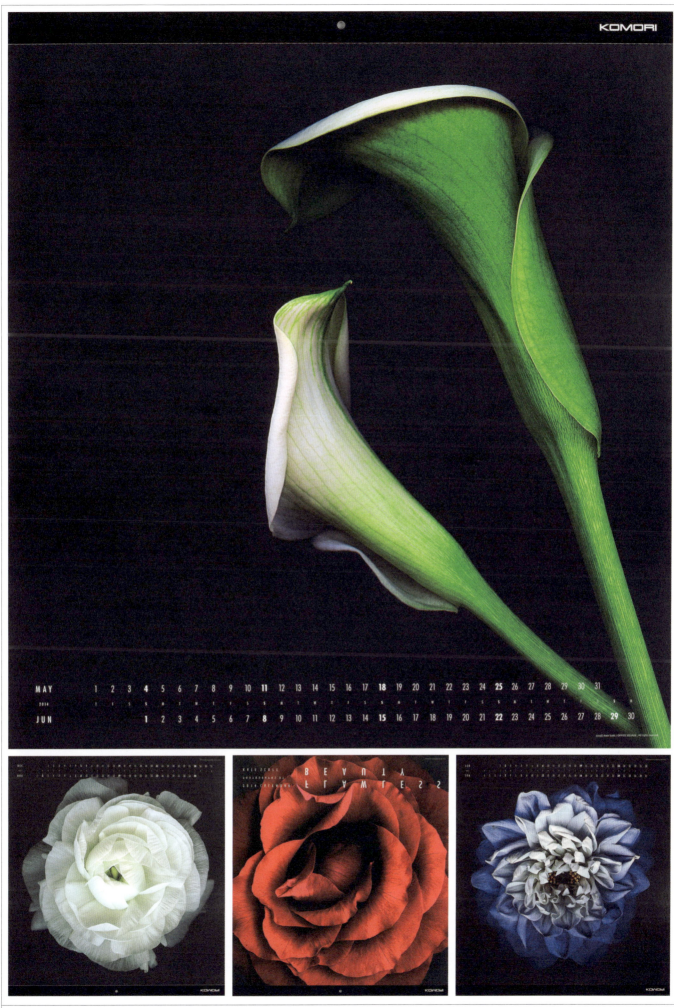

2014 KOMORI CALENDAR. Photographs by Kate Scott / OFFICE SQUARE LLC.

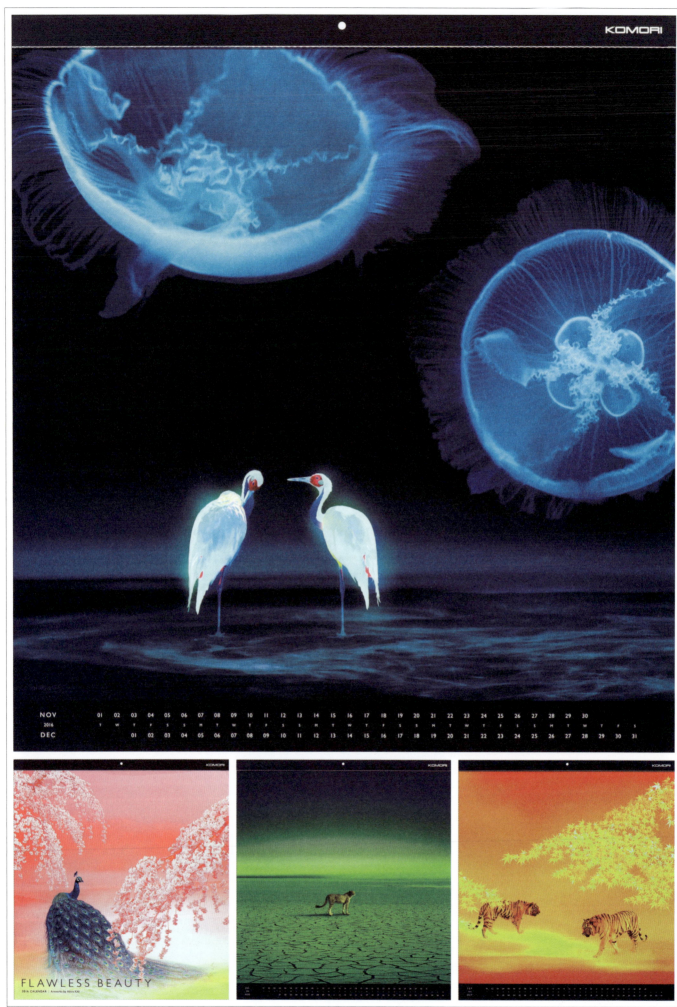

2016 KOMORI CALENDAR. Artwork by Akira Kai

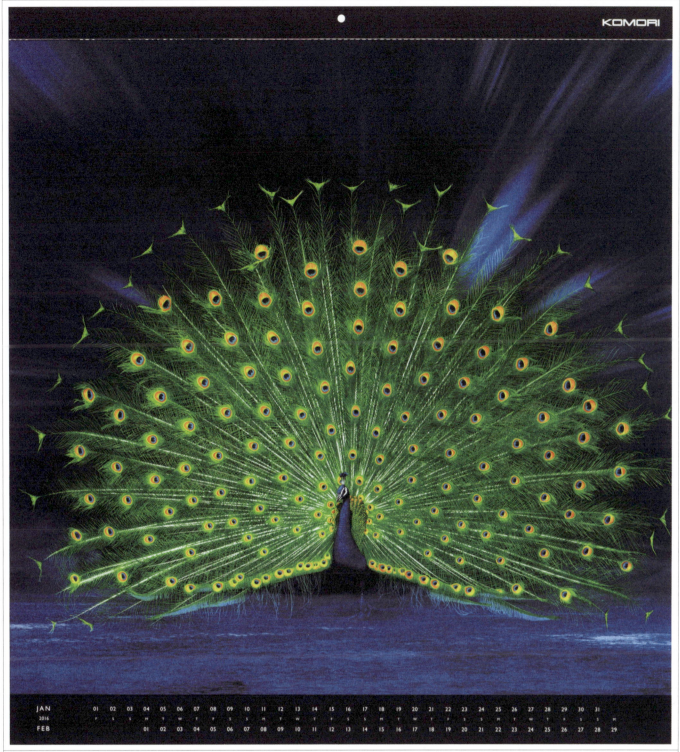

2016 KOMORI CALENDAR. Artwork by Akira Kai

MAY 01 02 03 04 05 06 07 08 09 10 11 12 13 14 15 16 17 18 19 20 21 22 23 24 25 26 27 28 29 30 31

JUN 01 02 03 04 05 06 07 08 09 10 11 12 13 14 15 16 17 18 19 20 21 22 23 24 25 26 27 28 29 30

2015 KOMORI CALENDAR. Photographs by Christopher Marley ©Pheromonedesign.com / OFFICE SQUARE LLC.

Derwyn Goodall: Making Work That Matters

THE BRAND GOODALL INTEGRATED DESIGN CREATED FOR MATRIX TECHNOLOGIES SUCCESSFULLY DIFFERENTIATED MY COMPANY IN A SEA OF DIRECT AND INDIRECT COMPETITION.
Bill Dubé, *Chief Executive Officer, Hayward Gordon*

I'VE HAD THE PLEASURE OF WORKING WITH DERWYN FOR OVER TWO DECADES. THE MAN IS HIGHLY CREATIVE, KNOWLEDGEABLE, INTELLIGENT, AND CLASSY. I NEVER TURN DOWN AN OPPORTUNITY TO VISUALLY PROBLEM-SOLVE.
Mike Carter, *Illustrator, Mike Carter Studio Inc.*

CHOOSING GOODALL INTEGRATED DESIGN HAS BEEN ONE OF THE BEST DECISIONS WE'VE MADE. WE HAVE EXPERIENCED THE VERY BEST IN WORLD-CLASS SERVICE, CREATIVE DESIGN, AND UNPARALLELED BRAND DIRECTION.
Phil Newman, *President, COBMEX Apparel Inc.*

DERWYN IS AN EXTREMELY TALENTED CREATIVE DIRECTOR AND IS ONE OF THE BEST I HAVE EVER WORKED WITH. HE HAS A UNIQUE ABILITY TO READ CLIENTS AND DELIVER CONCEPTS THAT DELIGHT.
Susan Elliot, *Professional Coach & Communications Consultant, Adler*

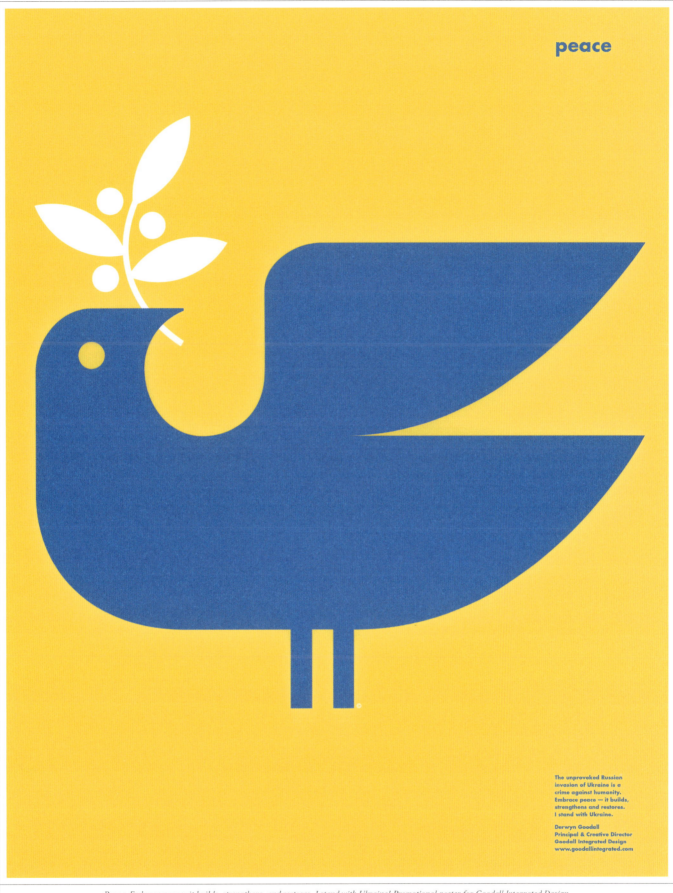

Peace. Embrace peace; it builds, strengthens, and restores. I stand with Ukraine! Promotional poster for Goodall Integrated Design.

Introduction by **Andrej & Katarina Jenik** *Owners, Jenik Art Consultants*

A few years ago, we decided to modernize our brand and realized it was crucial to find a professional designer who'd accurately capture the context of our business and also satisfy our aesthetic criteria. We chose Derwyn as our designer and are thrilled that we did! Derwyn is an attentive and patient listener. He became very familiar with our business and used this knowledge as the foundation of his design process. Derwyn's process is very iterative, and we were involved in it every step of the way. We love our new visual identity and brand refresh; it's literally everything that we wanted. On top of that, Derwyn was just so pleasant and straightforward to deal with, which made the whole process extremely enjoyable. We remain his happy customers and are always glad to recommend his services.

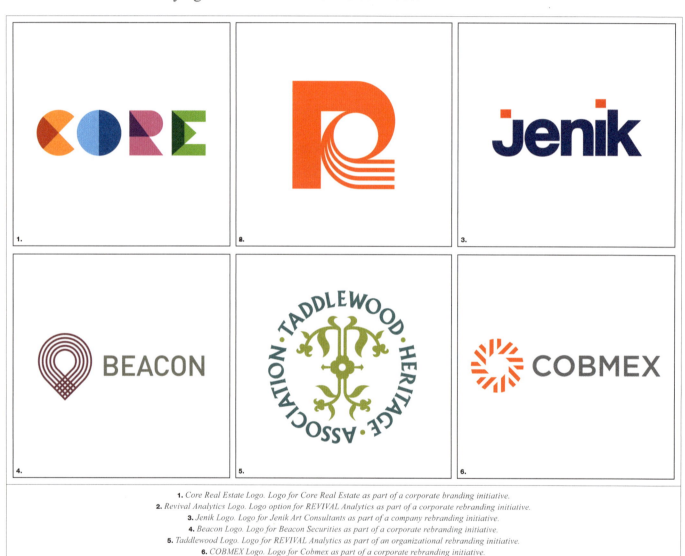

1. *Core Real Estate Logo. Logo for Core Real Estate as part of a corporate branding initiative.*
2. *Revival Analytics Logo. Logo option for REVIVAL Analytics as part of a corporate rebranding initiative.*
3. *Jenik Logo. Logo for Jenik Art Consultants as part of a company rebranding initiative.*
4. *Beacon Logo. Logo for Beacon Securities as part of a corporate rebranding initiative.*
5. *Taddlewood Logo. Logo for REVIVAL Analytics as part of an organizational rebranding initiative.*
6. *COBMEX Logo. Logo for Cobmex as part of a corporate rebranding initiative.*

COMBINE CONCEPT AND STRATEGY WITH BEAUTY IN MEANINGFUL WAYS TO HELP CLIENTS REACH THEIR COMMUNICATION GOALS.

Derwyn Goodall, *Founder & Designer, Goodall Integrated Design*

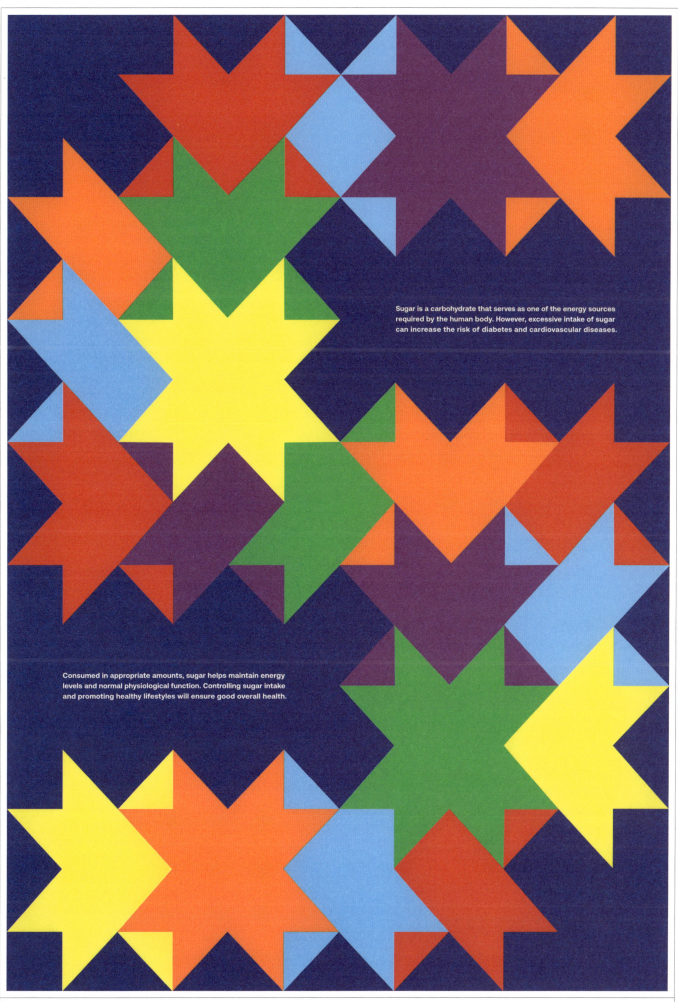

Sugar Energy. Sugar is one energy source required by the human body. Controlling sugar intake will ensure overall good health.
My entry for the 2023 Sweet & Health International Invitational Poster Design Exhibition held in Taiwan.

Q&A: Derwyn Goodall, Founder & Designer, Goodall Integrated Design

What inspired or motivated you to have a career in design?
Record album artwork was the gateway to my design career.

What is your work philosophy?
Combine concept and strategy with beauty in meaningful ways that help clients reach their communication goals.

Who is or was your greatest mentor?
My mentors are my design heroes: Milton Glaser, Massimo Vignelli, Wim Crouwel, Paul Rand, Alex Steinweiss, Reid Miles, and David Stone Martin.

Who were some of your greatest past influences?
See mentors above.

What is it about design that you are most passionate about?
I'm passionate about creating socially conscious designs that help people and organizations and working with my clients to succeed by helping them achieve their communication goals.

Goodall Integrated Design covers various areas of design, including interactive design, packaging, print communications, and more. Do you have a particular favorite field, and if yes, what?
I like branding programs that include all communication touchpoints.

What is the most difficult challenge you've overcome to reach your current position?
Maintaining a viable business through COVID-19.

Who among your contemporaries today do you most admire?
Paula Scher, Jonathan Barnbrook, Brian Collins, Micheal Bierut, and Jennifer Sterling.

What would be your dream assignment?
To rebrand an art museum or large-scale gallery.

Who have been some of your favorite people or clients you have worked with?
Canada Post, Ministry of Canadian Heritage, Phil Newman (COBMEX), Jenik Art Consultants, Continuum Contemporary Music, REVIVAL Analytics, Integrated Asset Management, and Dr. Jeff Wilson (Brain Shift).

What are the most important ingredients you require from a client to do successful work?
I require trust (knowing that I am a partner, not a supplier), enough time to develop the best work, and a realistic budget.

What is your most outstanding professional achievement?
Winning a Platinum Award for my poster in Graphis' Designers for Peace competition and being elected as a member of the Governing Council to the RCA/ARC (Royal Canadian Academy of Arts).

What is it like running your own design firm compared to designing for a bigger company?
Time is an issue: There's more pressure to balance creative work with business goals.

What is the greatest satisfaction you get from your work?
Knowing that I have been a part of a client's communication team and helped them achieve their business goals.

What part of your work is the most demanding, considering your position?
Business development and time management.

What professional goals do you still have for yourself?
To continue to do meaningful work that matters.

What advice do you have for students starting out today?
Find your passion; it will take you where you ultimately want to be.

What interests do you have outside of your work?
Travel, music, audio, and fitness.

What do you value most?
Honesty, integrity, and collaboration.

What would you change if you had to do it all over again?
I would have started my own business earlier.

Where do you seek inspiration?
Art, literature, music, travel, and close friends.

How do you define success?
I don't define it in monetary terms, but in knowing that I have contributed to society in meaningful ways.

Where do you see yourself in the future?
Still being creative. Where and how? I cannot predict!

Goodall Integrated Design www.goodallintegrated.com

FIND YOUR PASSION; IT WILL TAKE YOU TO WHERE YOU ULTIMATELY WANT TO BE.

Derwyn Goodall, *Founder & Designer, Goodall Integrated Design*

SUMMER DAYS ARE AHEAD ALWAYS MAINTAIN YOUR SOCIAL DISTANCE

Summer. Promotional poster for Goodall Integrated Design produced during Covid, reminding people to maintain their social distance to help end the pandemic.

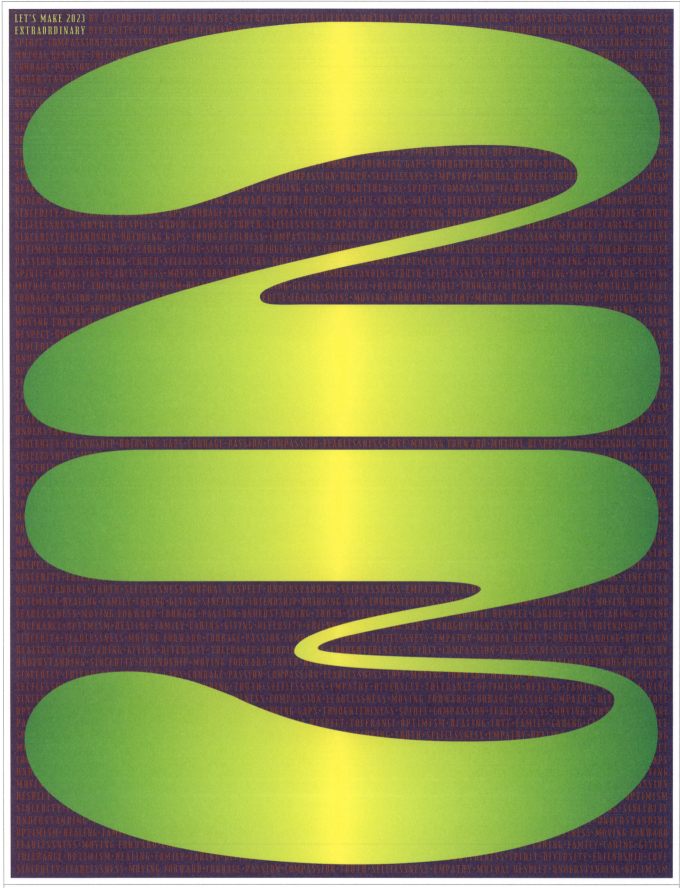

23. Let's make 2023 extraordinary! Holiday poster promotion for Goodall Integrated Design.

A rising toll of protesters have been killed by Iranian authorities since demonstrations triggered by the death of Mahsa Jina Amini who was arrested and then later died in police custody. Women-led protests across Iran have been met with violence. And yet, Iranian women and their allies bravely persist. Support their struggle for freedom by calling for an immediate end to violence. This is a very important moment for the global community to unequivocally demonstrate their support for women's rights by standing in solidarity with every Iranian women and girl.

Woman, Life, Freedom. Poster for an awareness campaign through ThinkUp Editions in Dortmund, Germany.
The campaign promotes the women's movement through art and culture in European countries and beyond.

TOLERANCE
INCLUSIVENESS
OPENNESS
ACCEPTANCE
COMPASSION
FAIRNESS

TRUE CANADIAN VALUES

Goodall Integrated Design
Derwyn Goodall
Principal/Creative Director
goodallintegrated.com

good all

EQUALITY
RESPECT
DIGNITY
FREEDOM
GRATITUDE
HOCKEY

EH OK. Promotional poster showcasing Canadian values for Goodall Integrated Design.

10x10. Poster for the "10x10" Global Poster Exhibition to be held in Shanghai. The exhibition displayed the work of 100 designers, with ten each from ten different regions around the globe.

Paul Rand. A homage to Paul Rand and a promotional poster for Goodall Integrated Design.

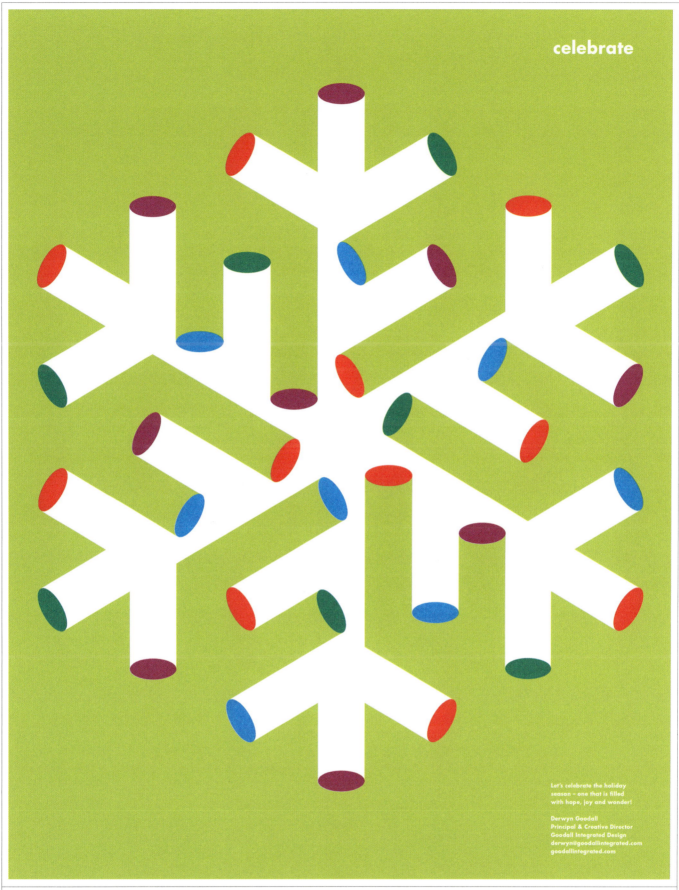

Celebrate. Let's celebrate the 2022 holiday season! Holiday poster promotion for Goodall Integrated Design.

ADVERTISING

52 SUKLE ADVERTISING / USA

Polio deaths in Wyoming

1951　1953　1955　1957　1959　1961

THANK A VACCINE

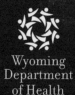

Wyoming Department of Health

Sukle Advertising: The Next Great Idea

IN 2017, I SPENT TIME JUDGING A SHOW WITH MIKE. I WAS STRUCK BY HIS AUTHENTICITY, NOT ONLY AS A CREATIVE PERSON BUT ALSO AS A HUMAN BEING. YEAR AFTER YEAR, HE CONSISTENTLY PRODUCES AN IMPRESSIVE BODY OF WORK.

Zak Mroueh, *Founder & Creative Chairman, Zulu Alpha Kilo*

MIKE IS ONE OF THE BEST CREATIVE MINDS IN THE BUSINESS. NOT ONLY DOES HE THINK OUTSIDE THE BOX, BUT HE ALSO PRODUCES REAL RESULTS IN HIS AMAZING CAMPAIGNS.

Benjamin Douglas Ray, *VP BD & Digital Engagement, Spotsurfer*

MIKE'S WICKED CREATIVITY, KEEN UNDERSTANDING OF DENVER'S UNIQUE MARKET CHARACTERISTICS, AND SHEER GALL LED TO AN ADVERTISING CAMPAIGN THAT FOREVER CHANGED HOW OUR CITY VALUES WATER AS A PRECIOUS RESOURCE.

Trina McGuire-Collier, *Former Director of Communications & Marketing, Denver Water*

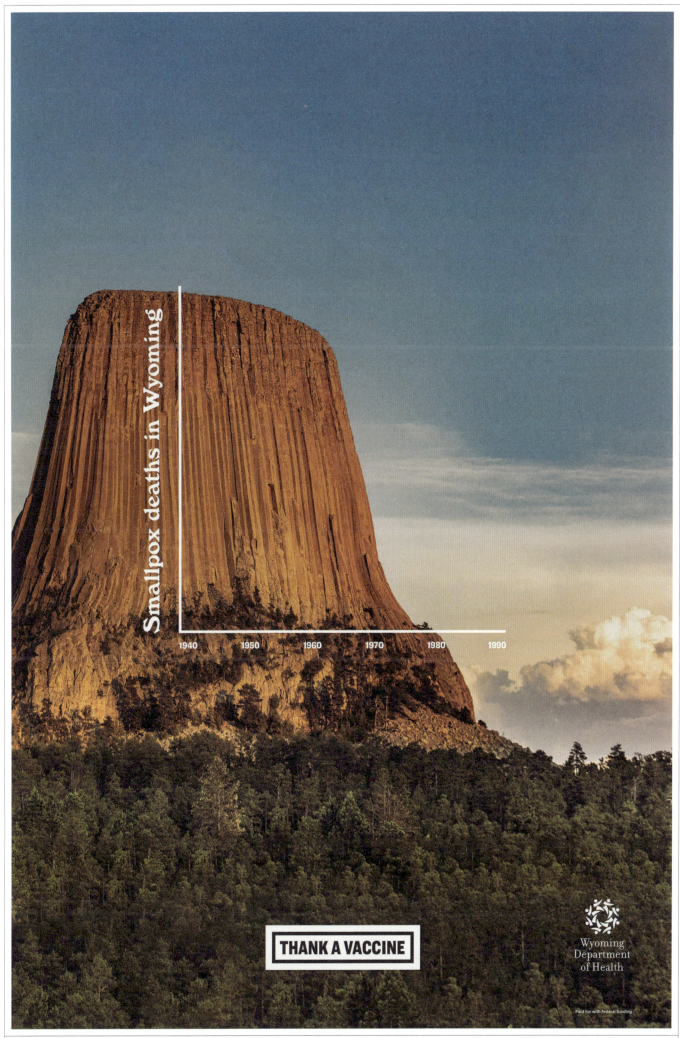

Wyoming Department of Health. "Thank a Vaccine" 2023

Introduction by **Rosemary Dempsey** *Director of Communications, Great Outdoors Colorado & Generation Wild*

Mike Sukle, the creative director and founder of Sukle Advertising, has the power to change the world. His process starts with a human insight or a revealing truth. He taps into a cultural moment, seeing an opportunity or a challenge—and however enormous it is, it won't be a match. His ideas are responsive, demanding attention and making you stop to consider or feel like a part of something bigger. It's been the ultimate privilege and pleasure of my career in marketing and communications to witness his creative mind at work. The state of Colorado and its next generation of young people have had the benefit of his big, inspiration-creating, life-changing brain, and for that, I'm so grateful.

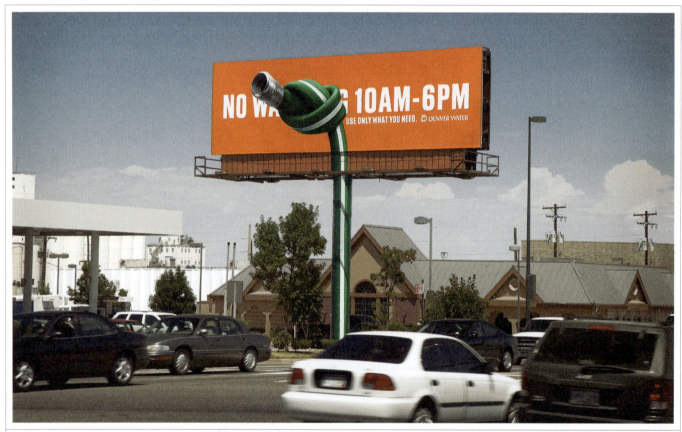

(Above) Denver Water. "Use Only What You Need" 2008 / (Opposite page) Denver Water. "Use Only What You Need" 2014

Q&A: Mike Sukle, Founder & Chief Creative Officer, Sukle Advertising

What has inspired or motivated you in your career?
The opportunity to develop the next great idea. We are fortunate to have a job where we sit around, tell jokes, and come up with crazy things. Then, we get to turn them into reality. When you hit on the right idea, it's like magic. Everyone knows and talks about an ad. They look forward to seeing it. And it's just an ad. But it's something incredibly difficult to do well. We're proud of the work we create. I can't think of anything more interesting to do for my career.

What is your work philosophy?
Work hard, and good things happen. This isn't the type of career that you can turn on and off. Creating exciting and practical work is hard; it takes concentration and time. First, you must have an idea worth a person's time to notice. It will speak to a person's heart and head if it's good. Secondly, you must produce it flawlessly. There are so many points along the way that a good idea can get screwed up or watered down. All of that takes patience and a lot of elbow grease.

What is it about advertising that you are most passionate about?
Creativity is a powerful tool. It can shape beliefs and alter behaviors like nothing else out there. It's also at the core of humanity and something we should always strive for.

Who is or was your greatest mentor?
When I started my career as a designer, I had the privilege of working for Tom Bluhm at IBM. Tom was the head designer at the Boulder Design Center. He ingrained a strong sense of Swiss design into my approach. The idea that the content of the work should be the focal point and the design is there to support it is something we still strive for. He was a craftsman, and that quality was always present in his work. But Tom taught me about far more than design. He fought for the work he believed in. He didn't easily bend to corporate management, who didn't always see eye to eye with him. Tom was one of the good guys. He was always positive, always curious, and always learning. If you Google him, you'll find he went on to study at the Basel School of Design under renowned designers

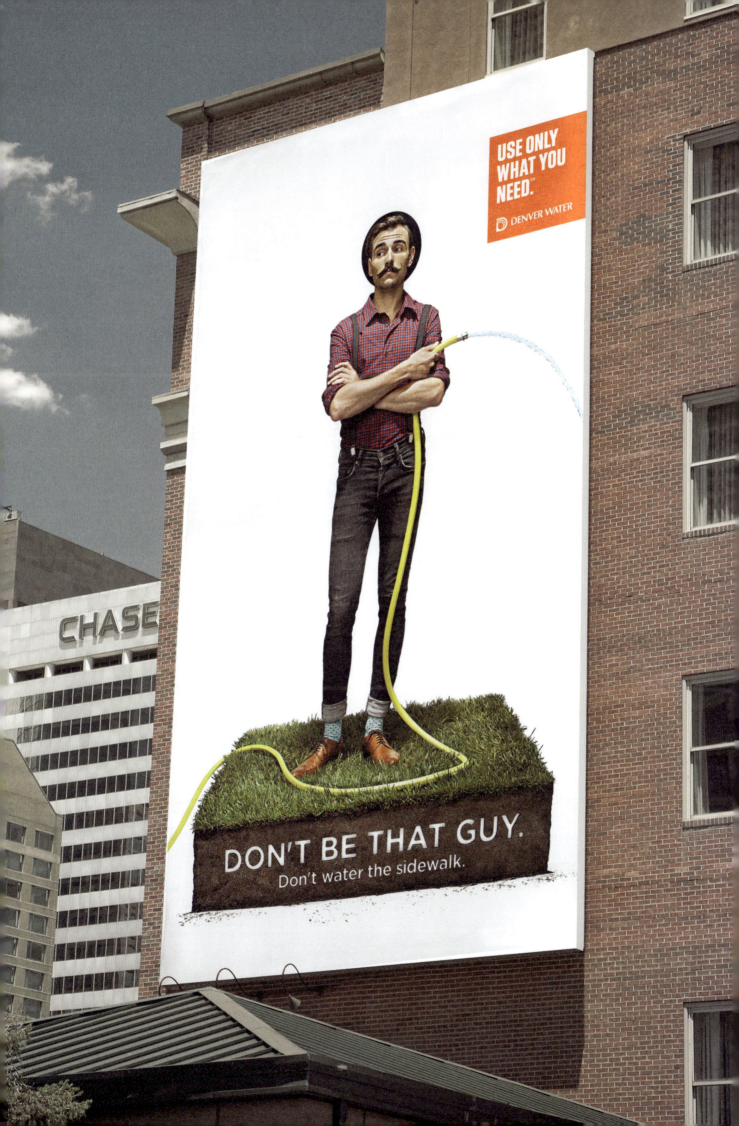

Q&A: Mike Sukle, Founder & Chief Creative Officer, Sukle Advertising

Armin Hofmann and Wolfgang Weingart. Tom later returned to IBM and became the chief liaison between IBM management and Paul Rand. He also was the chair of communication design at ArtCenter Europe.

My other key mentor, Jim Glynn, is also one of my best friends. Jim is an amazingly talented copywriter. When I started the agency, Jim was a creative director at a competing agency in Denver. Shortly after, that agency made the biggest mistake of their life when they fired him. I was the first person he called. We worked together for years. Jim was one of the fastest creative people I've ever been around. He always got straight to the point and created work that spoke to the essence of what we were trying to communicate. He would quickly understand the problem that needed to be solved and address it in a surprising yet simple way. Jim was not only a talented writer, but he was also one of the best strategic minds I've worked with. And no writing job was beneath him. He wrote a beautiful short film for us, but he also wrote websites and social posts. Jim just got stuff done and did all of it well. You can learn a lot from a person like him.

Who have some of your greatest past influences been?
Jeff Goodby and Rich Silverstein, Dan Wieden, Alex Bogusky, Ari Merkin, Woody Pirtle, and Paula Scher. And I've got to put my parents up there, too. My dad came from Slovenia, survived WWII, ran a successful business, and put six kids through college. My mom worked harder than maybe anyone I know. She helped run the family business. She was an amazing cook and a caring and independent mom.

Who among your contemporaries today do you most admire?
There are so many people creating great work today. We've been honored to work with Tore Frandsen, a Danish film director. His passion for making films was inspiring. His work is beautifully cinematic. His humor is authentically Danish. Gold Lions and Grands Prix are all part of his illustrious career.

I've always been a huge fan of Zulu Alpha Kilo and its founder, Zak Mroueh. Zak is one of the nicest people you'll ever meet, and his agency's work is incredible. They push the limits of creativity well beyond the norm. Take one look at their website, and you'll immediately see what I'm saying. Not only do they do great work, but they also take a strong stand against doing spec work in pitches. Principled people always rate high in my book.

Who have been some of your favorite colleagues or clients?
This could be an incredibly long list, and I'm certain I'd miss people who should be mentioned. That said, there are two colleagues at the top. They do not get the acclaim that an art director or copywriter receives, nor do they get the primetime stage in front of clients. But the work that our agency produces wouldn't be the same without either of them.

Michon Schmidt is our director of production and has been with the agency for over 20 years. She's the reason we get to work with talented artists from around the world and produce beautiful work regardless of unreasonable obstacles. And her laugh can fill a room.

The other person is Matt Carpenter, our digital artist. He's been with the agency for a long time as well. When he first came, we thought we had a competent production artist on our hands. Matt quickly made us rethink that assessment. His artistic, animation, and digital skills are outstanding. His ability to figure out how to create something we've never done before is unmatched. Because of these two people, Sukle is a better agency.

As for clients, these folks should really be mentioned under the mentor question. We've had the honor of working with some of the brightest minds in their respective industries. They all were fearless leaders who wanted to accomplish something big.

You wouldn't immediately think that one of the smartest marketers we've worked with was at a local water utility, but that was where we met Trina McGuire-Collier. Trina worked for Denver Water and led the campaign that changed Denver's culture. The "Use Only What You Need" campaign has been acknowledged worldwide for its effectiveness and creativity. Trina was a true believer and one of the best leaders we've ever gotten to work for.

Aaron Kennedy, the founder of Noodles & Company, created a legacy that changed the fast-food industry. We worked with Aaron for over ten years and helped his brand grow from two restaurants to over 200. Aaron is a great marketer, businessperson, and human being.

Rosemary Dempsey is the director of communications at Great Outdoors Colorado and one of the funniest people you'll ever know. She'd be a famous standup comic if she weren't so good at her job. But Rosemary's true passion is helping others, especially the future generation. She is the inspiring force behind Generation Wild, a campaign to reconnect kids to the outdoors.

What are the top things you need from a client to do successful work for them?
They must be smart. They need to be kind. And they must aspire to something greater.

What is the most difficult challenge you've overcome to reach your current position?
I'm sure everyone else who has ever owned an agency has encountered the same challenges I have: hiring the right people, pitching business, producing exciting work that makes a difference for your clients, etc. As difficult as all of these are, none of them compare with the loss of my son. Cole was 14 years old and a block away from home when a drunk driver hit him. That day changed my life forever. The pain is unimaginable. Since then, I've met far too many other parents who have lost a child and are dealing with the grief. I wish I could do more for them.

This leads to another question you asked. "What do you value most in life?" Time with my family and friends. Everything else can wait.

What do you consider your most outstanding professional achievement so far?
We're a small agency in the Mountain Time Zone. We don't have brands like Apple, Nike, or Ikea on our roster, yet people around the world have seen and appreciated our work. We're proud of that.

What about your work gives you the greatest satisfaction?
Solving the really big problems. It's very satisfying when a client comes to you with something important, and you find the idea that changes the game for them.

What professional goals do you still have for yourself?
Every day, I think the world needs us more than the last. We work for brands and organizations that create positive change, improve people's lives, and not just make a quick buck. We're working more and more on climate change issues, and if we can make a dent in that, I'll sleep better. We believe our work brings people together, and that's needed more than ever. We need the good to shine through, and creativity is a powerful weapon to do that.

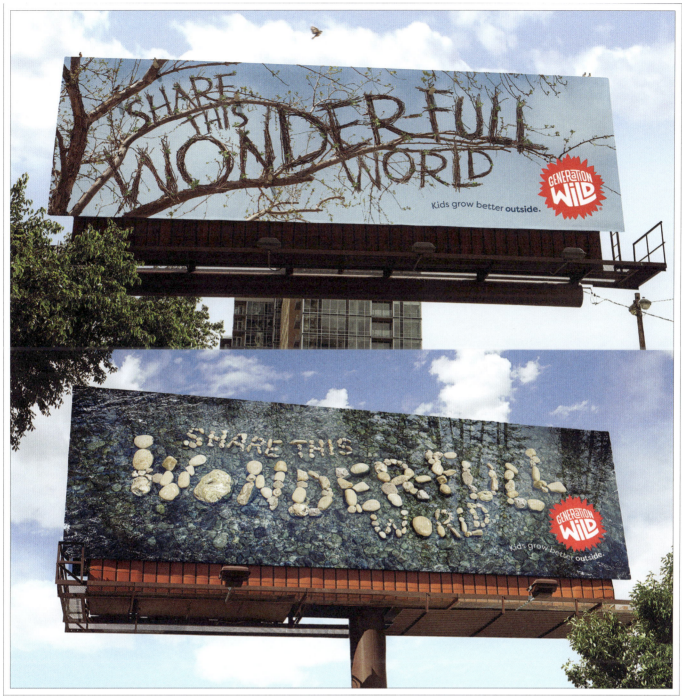

Great Outdoors Colorado. Generation Wild, "Share This Wonder-Full World" 2023

What advice do you have for students starting out today?
You don't know everything, and you never will. So, never stop learning. Learn from your family and kids. Listen to the opinions of people who aren't anything like you. Read. Watch movies. Listen to comedians. Ask people what they think about your work. You don't have to agree with it, but you do have to know how others are interpreting it.

What interests do you have outside of work?
We are so lucky to live in Colorado. It's a beautiful and inspiring place to live. When I'm not working, I try to spend as much time outdoors as possible: running, hiking, camping, paddleboarding, skiing, etc. Nothing is better in the depths of winter than getting outdoors in the sunshine and blue sky.

What would you change if you had to do it all over again?
If I had to do it all over again, I would take as good of care of our business as we do our clients' business.

Where do you find inspiration?
This is the one business where you can apply experiences from far and wide. Nature. Good food. Culture. The best inspiration may come from humanity. It's inspiring to watch people for the good, bad, and funny, or listen and observe kids; they have some of the best jokes. Kids haven't learned to be boring yet. Right before my first son was born, a photographer and friend gave me the best advice ever. He said when a little kid is getting into the car, it might take them 15 minutes. You can either get uptight and frustrated, or you can simply watch them, and it will probably be hilarious. That was some of the best advice I've ever gotten.

How do you define success?
It's pretty simple: Have we helped or hurt the world? Did we do something that made someone laugh or think? Is our work better today than it was yesterday?

Sukle Advertising www.sukle.com

WYOMING DEPARTMENT OF HEALTH

(Top) Wyoming Department of Health. Thank a Vaccine, "Hairy Times" 2023
(Bottom) Wyoming Department of Health. Quit Now, "Free Gum" 2014

CREATIVITY IS A POWERFUL TOOL. IT CAN SHAPE BELIEFS AND ALTER BEHAVIORS LIKE NOTHING ELSE OUT THERE. IT'S ALSO AT THE CORE OF HUMANITY AND SOMETHING WE SHOULD ALWAYS STRIVE FOR.

Mike Sukle, *Founder & Chief Creative Officer, Sukle Advertising*

EXEDE SATELLITE INTERNET, "GRANDMA"

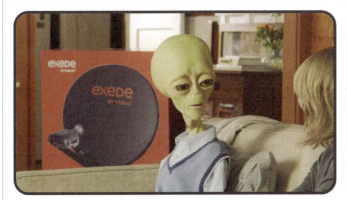
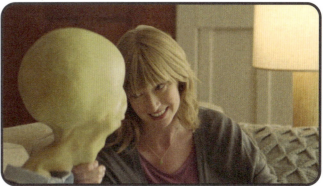
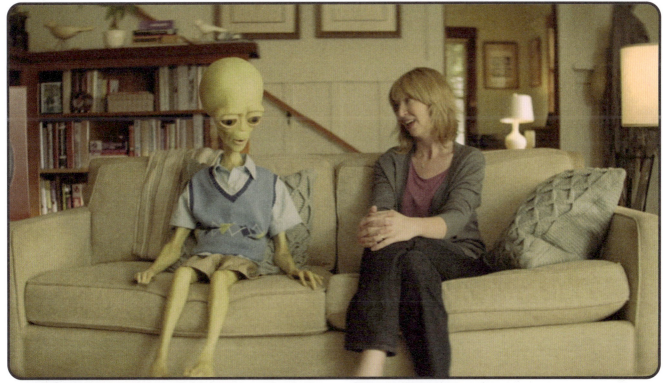

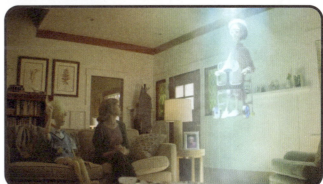
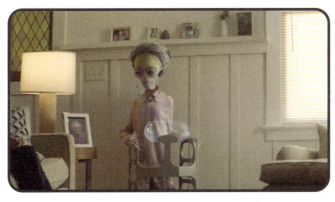

Viasat. Exede Satellite Internet, "Grandma" 2014

¿Hablas español?

PLEASE LEAVE WHAT YOU FIND.

You only get 26,320 days, more or less. How will you spend them?

scarpa.com/terminator-x

You only get 26,320 days, more or less. How will you spend them?

SCARPA
NESSUN LUOGO E' LONTANO

P

PHOTOGRAPHY

66 PETER SAMUELS / USA

80 HOWARD SCHATZ / USA

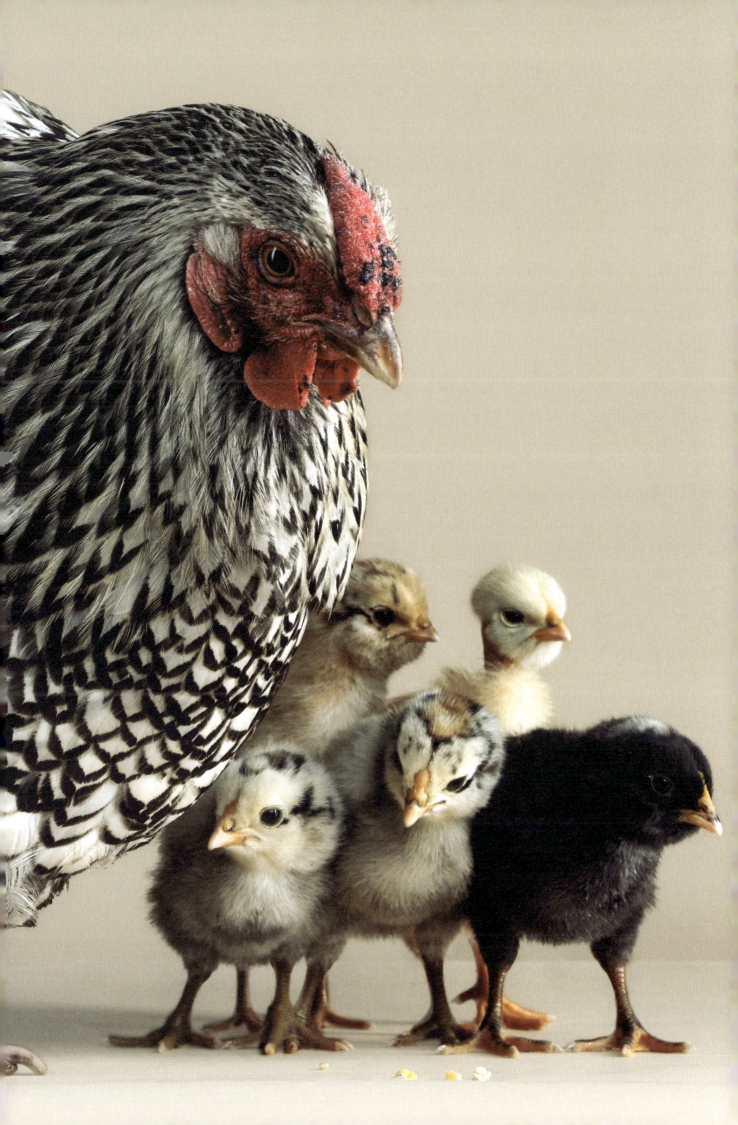

Peter Samuels: Perfecting Animal Portraiture

EACH SHOT REFLECTS METICULOUS PRECISION, REVEALING PRODUCT NUANCES IN STUNNING CLARITY. A CONSUMMATE PROFESSIONAL, PETER IS ADEPT AT CAPTURING BEAUTY IN THE MINUTEST OF DETAILS AND WITH CREATIVE BRILLIANCE.
Adam Brodsley, *Principal, Volume Inc.*

PETER SAMUELS' WORK IS EXTRAORDINARY. HE MANAGES TO BRING FEELING, WONDER, AND JOY INTO EACH IMAGE; HIS EYE AND ATTENTION TO DETAIL ARE EXEMPLARY.
Karen Rawden, *Psychotherapist, Karen Rawden Counseling & Psychotherapy*

IT IS RARE TO FIND A PHOTOGRAPHER WHO SO GENUINELY REVEALS HIS SUBJECTS AS HE DOES.
RJ Muna, *Photographer*

HIS WORK FEELS GROUNDED IN THE ROOTS OF OUR CRAFT, POSSIBLY INSPIRED BY KARSH OR PENN, BUT WITH THE EDGE OF TODAY'S AESTHETICS. SEEING HIS JOURNEY LAND ON AN EXPRESSION OF LOVE FOR ANIMALS IS BEAUTIFUL AND INSPIRING.
Adam and Robin Voorhes, *Photographers*

I AM IMPRESSED BY PETER'S REMARKABLE CRAFT AND PRECISION. HIS ABILITY TO MASTER THE TECHNICAL ASPECTS AND CAPTURE THE DISTINCT PERSONALITIES OF ANIMALS IN HIS PORTRAITS SETS HIS WORK APART.

PETER'S DEDICATION SHINES THROUGH IN EVERY PIECE, OFFERING A GLIMPSE INTO THE PERSONALITY OF HIS SUBJECTS.
Randel Ford, *Photographer*

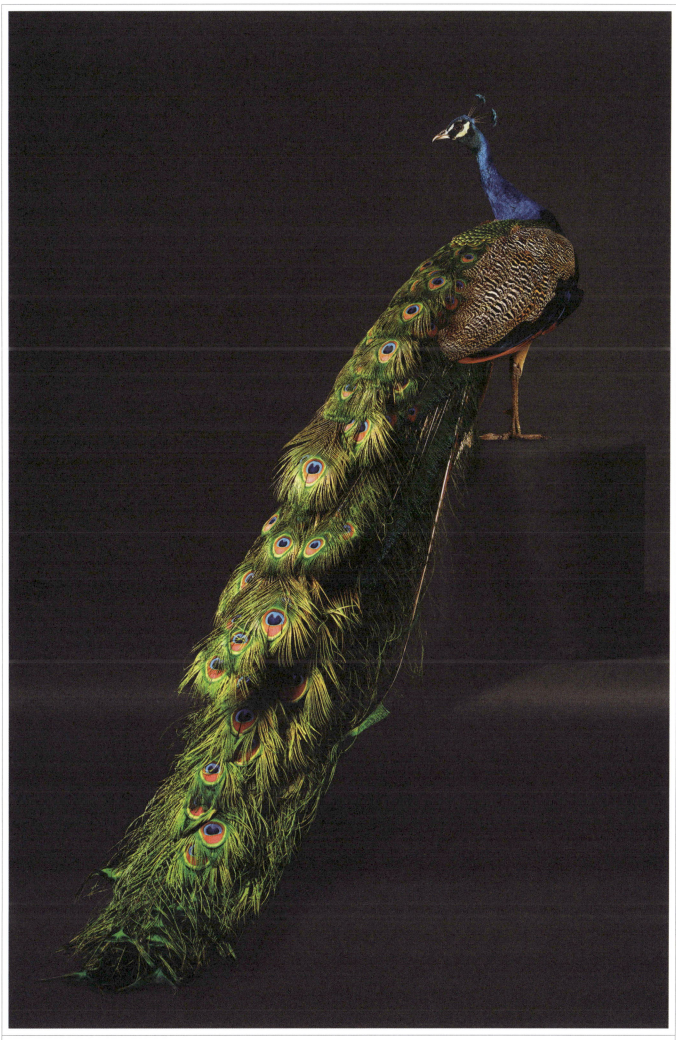

(Page 65) Wyandotte Chicken with Chicks, Storybook Animals Series / (Above) Blue Peacock, Private Commission

Introduction by Kevin Raich *Chief Marketing Officer, VaultLink*

Peter Samuels, a San Francisco-based photographer, brings magic and wonder to his work, transcending the realm of mere images. He creates gorgeous moments that seem to stop time and captivate the imagination with a sophisticated yet childlike charm. With a distinguished career as an award-winning advertising photographer, Peter's lens has graced countless campaigns, bringing brands to life with authenticity and mastery. Beyond his accolades, Peter is revered for his kind spirit and visionary approach to his craft. His photographs come to life with his genuine warmth and view of the world, with heart behind every image.

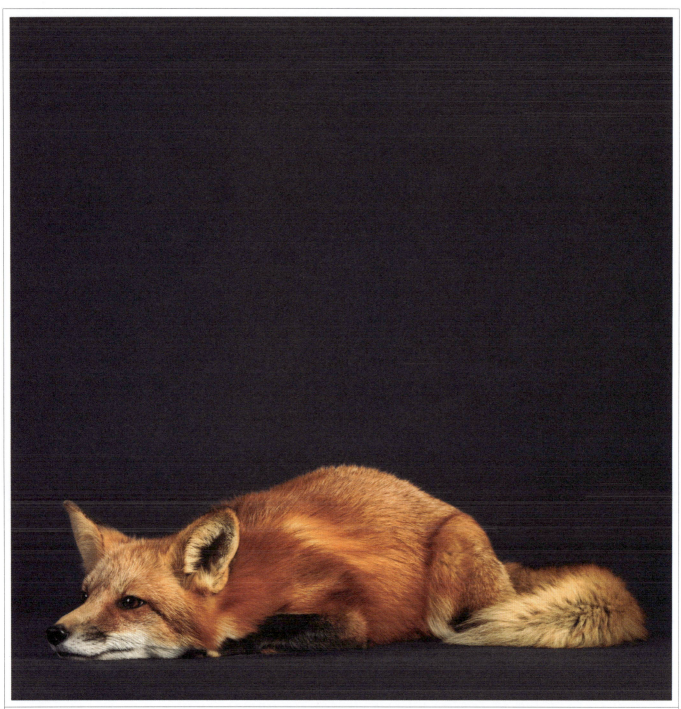

(Above) Red Fox, Storybook Animals Series / (Opposite page) Sebright Bantam Rooster, Storybook Animals Series

CREATING GREAT WORK THAT I'M PROUD OF IS THE FUEL THAT KEEPS ME WANTING TO DO MORE.

Peter Samuels, *Photographer*

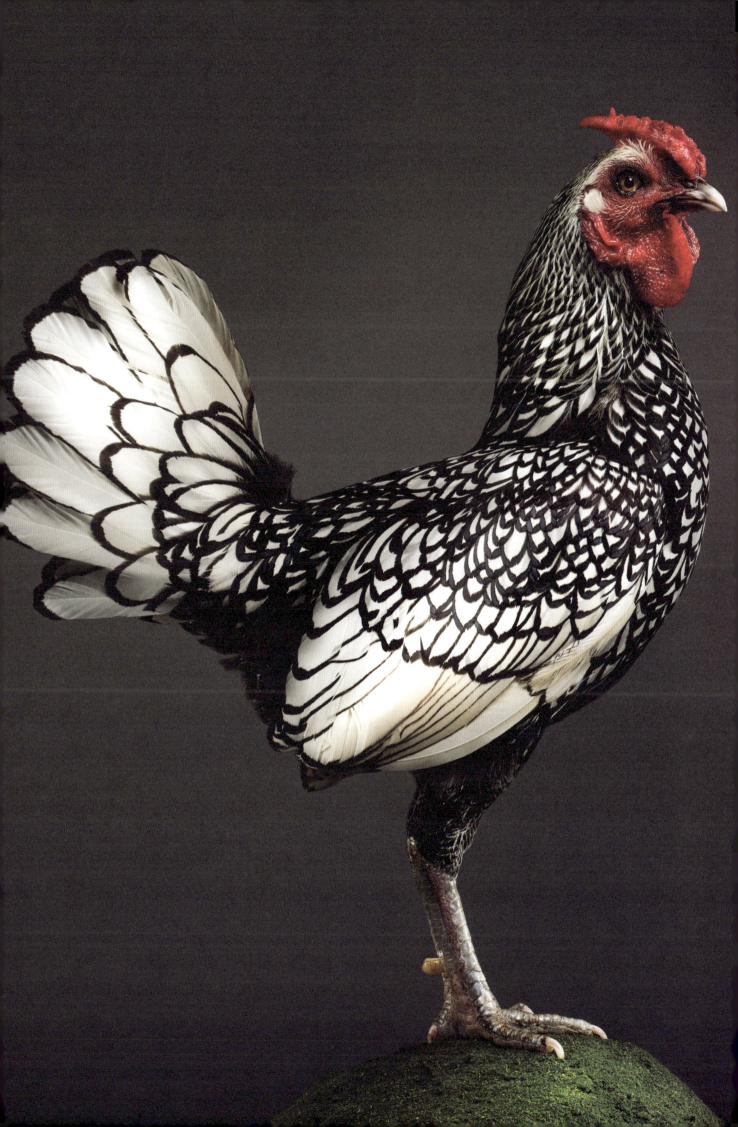

Q&A: Peter Samuels

What has inspired or motivated you in your career?
Early inspiration came through commercial and fine art photography books and magazines; I poured through anything I could find, from Irving Penn's impactful still life, Avedon's studio fashion work, and America West portraits to advertising imagery in magazines and awards books.

Some of my early motivation comes from a long-term illness I had through adolescence that kept me away from more physical activities. I could dive into photography independently, and I did with hutzpah. I knew my adult life would be better, fueled by the appreciation of being on the other side of illness; I couldn't wait to take full advantage of life and wasn't about to miss a beat in achieving my goal of being a successful professional photographer with a style that was my own.

What is your work philosophy?
Aside from always creating the best work possible, I've taken to heart what Walter Urie, a teacher at Orange Coast College in Southern California, taught me: "Always capture the essence of what or whom you're photographing, and pay your vendors." That simple philosophy has served me well.

Who is or was your greatest mentor?
I was fortunate to have several, but I want to mention two: Chuck Rausin and Stan Klimek. Chuck is a self-taught photographer who left his career as a metallurgist to become a photographer. I met him while starting college. I was learning through school, and he was learning by street. I assisted him and helped bridge the gap by providing technical knowledge, and he took me under his wing. My illness was sometimes an impairment, and he looked out for me. Chuck taught me his no-nonsense approach to work and life; he believed in me when I wasn't sure and gave me the confidence I needed to grow as a person and photographer.

Stan Klimek is an art and fashion photographer I met while he was teaching at Orange Coast College. Stan's the consummate photographer, a purest who creates beautiful, conceptually-based work with intent and technical artistry. Stan went on to become a sought-after Platinum/Palladium printer for artist greats such as Sally Mann, Robert Capa, Imogen Cunningham, and Greg Gorman, among others.

What is it about photography that you are most passionate about?
Creating great work that I'm proud of is the fuel that keeps me wanting to do more.

What camera do you use and why?
I'm currently shooting with the Sony A1, an excellent camera with spectacular AF. However, I won't hesitate to shoot with other cameras, especially medium formats such as the Fuji GFX 100 series or Phase One. And I can't wait to try the new Hasselblad X2D with its incredible image quality and focal plane shutter, allowing flash sync at all speeds. I'll own a medium format once the AF performance is at least a bit closer to what I need, so renting as needed is fine for now.

You're primarily known for your portraits of animals. What draws you to this type of photography?
With my personal work with the animals, it's a sense of playfulness that I see or project onto them inspired from the point of view of my childhood mind. That's the basis of my "Storybook Animals" series; creating those images brings me so much joy. The animals have unique, whimsical mash-up backstories comprising who they are and where they're from, mixed with what I see in them. Each results from deciding which animal to pursue and finding an owner with the right creature who's generous enough to host my production. Regardless of paying for their time, ranch people are busy and have difficulty understanding the cooperation I'll need from them. So, part of the process is getting them to be fans of my work and to believe in my mission of building this series. Indeed, that approach is sometimes frustrating, but I enjoy every step of the process. Of course, the best part is when the shoot comes together, and I'm finally on set, shooting and seeing the images come in.

What are the similarities and differences between shooting people and animals?
People are easier! Unless it's a toddler, then it's a toss-up, but toddlers generally take the prize for being more difficult than animals.

Who have some of your most significant past influences been?
In the realm of "created vs. found" imagery, I've leaned toward "created" from the start. I studied photographers like Philippe Halsman, with his produced portraits of Salvador Dalí jumping around with cats, as well as his portraits of Robert Oppenheimer and Albert Einstein, while Karl Blossfeldt's timeless botanical series using the north-facing daylight from a single window created images that spoke to me. In addition, there are Annie Leibovitz's portrait work—the beautiful surreal product—and the still life work of Paul Outerbridge from the 1920s. Also, the graphic and surrealist-inspired photographs of women for *Vogue* by Horst P. Horst are in there, too. Then there's Man Ray and László Moholy-Nagy, who experimented with light and form. Work from all of these artists represents deep-seated inspiration in my psyche.

Who among your contemporaries today do you most admire?
I appreciate and admire the work of Craig Cutler, James Day, RJ Muna, and the Voorhes, as well as the animal work of Tim Flach and Randal Ford. They all are "top of their game" photographers whose work I'll always respect.

What would be your dream assignment?
I would love to photograph camels or horses in Dubai for Ariat, Emirates Airlines. I would also love to go to Tibet and photograph a yak for a yak milk product.

A recent job involved photographing a hedgehog for a venture capital firm in Silicon Valley. That was cool because it was based on an old tale about foxes and hedgehogs. In essence, foxes are always scheming for their next meal while hedgies sit and wait. Someone used that as a business profiling tool, and my VC client identified with the hedgehog. I love to do work like that.

Who have been some of your favorite colleagues or clients?
Kevin Raich, a talented creative director/writer/director, is a valued close friend. Kevin always has fresh ideas and a clear, concise vision.

Jason Goldheim at Clorox is a client I always enjoy working with for their kitty litter products. Working with Jason is a pleasure and a collaborative experience.

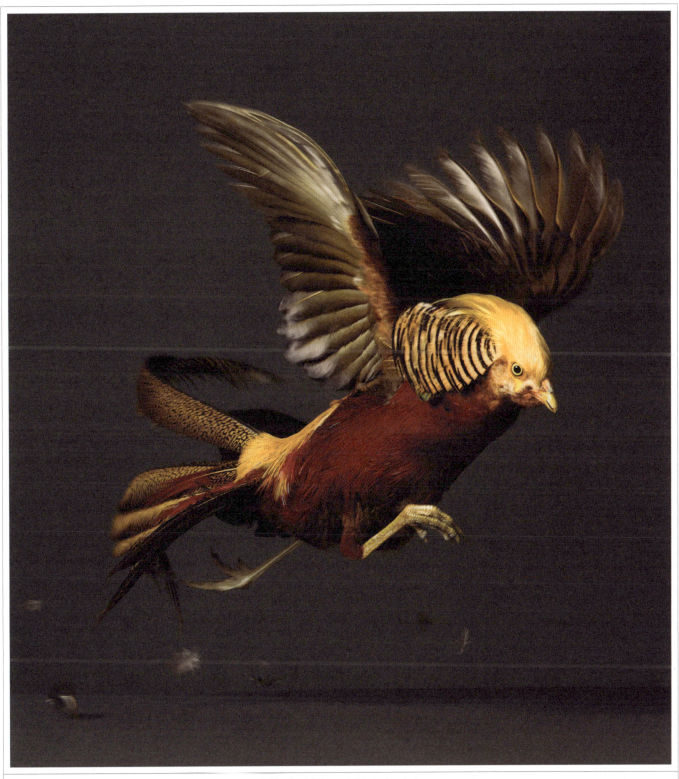

Golden Headed Pheasant, Private Commission

Having won multiple awards for your work, which one is the most meaningful to you?
Having my work on the cover of the 2024 Graphis Photography Annual is at the top since it's a book I've admired and coveted since early college when I could be seen sitting on the floor at a Rizzoli Bookstore devouring every page. Getting into the Communication Arts Photo Annual for the first time blew me away, and my work has been accepted for several years ever since. Awards like this are satisfying to my core and a sign that I'm on the right path; I'm eternally grateful for that.

Peter Samuels www.petersamuels.com
See his Graphis Master Portfolio at graphis.com.

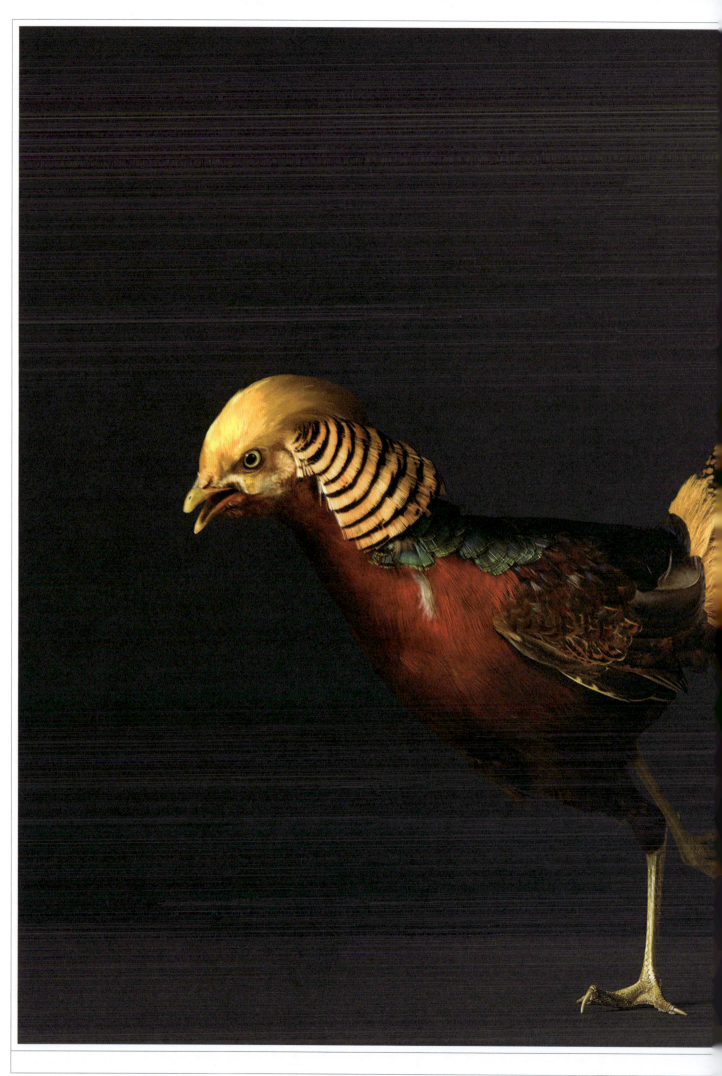

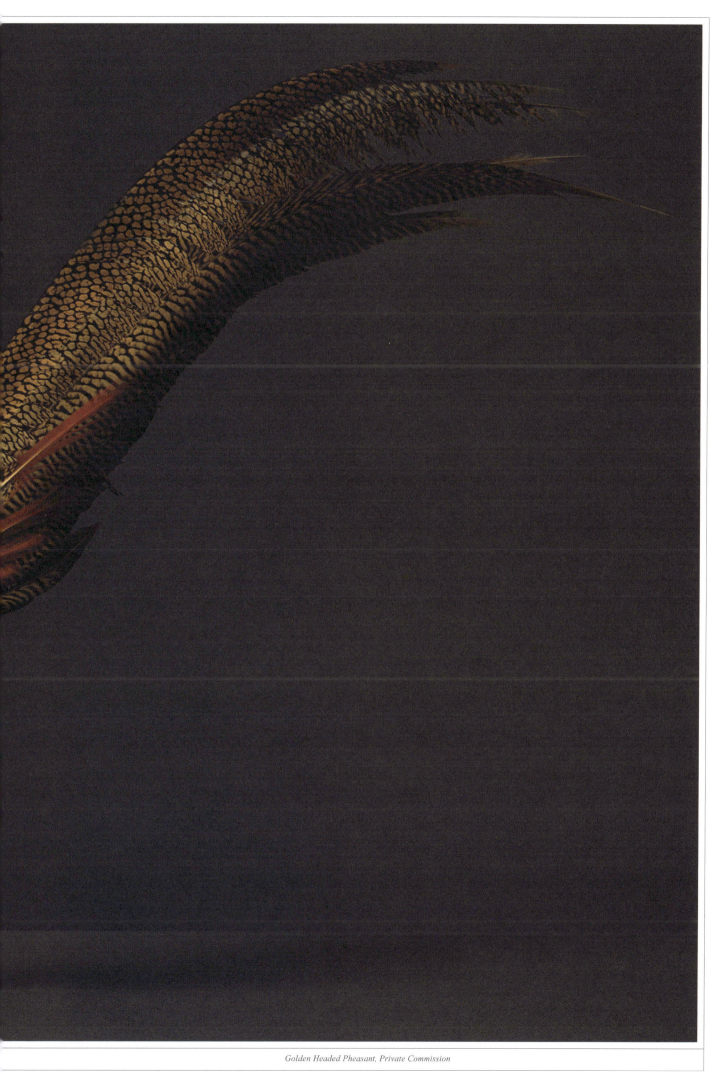

Golden Headed Pheasant, Private Commission

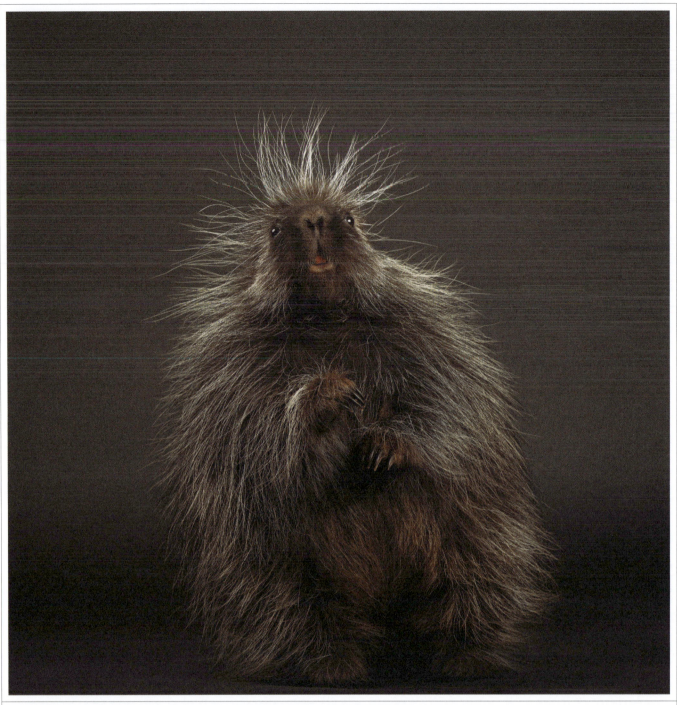
Baby Porcupine, Storybook Animals Series

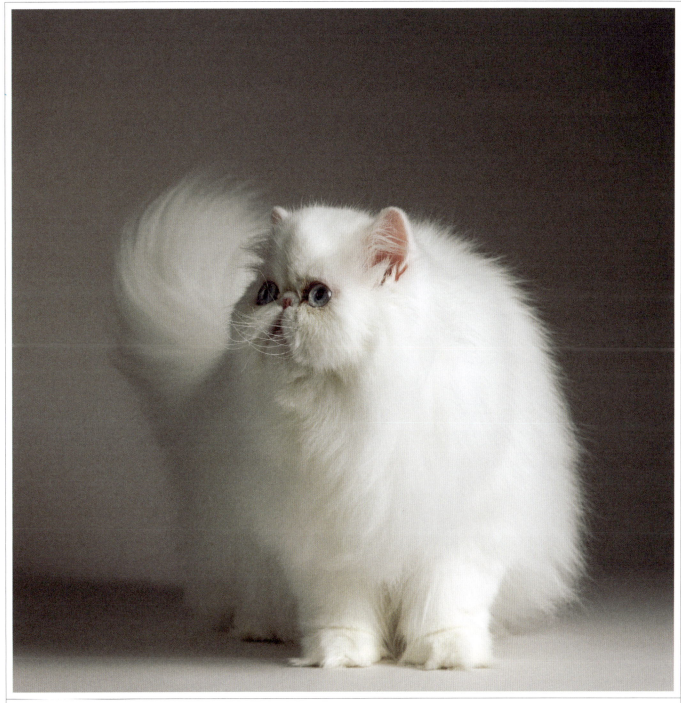

Client: Clorox Kitty Litter

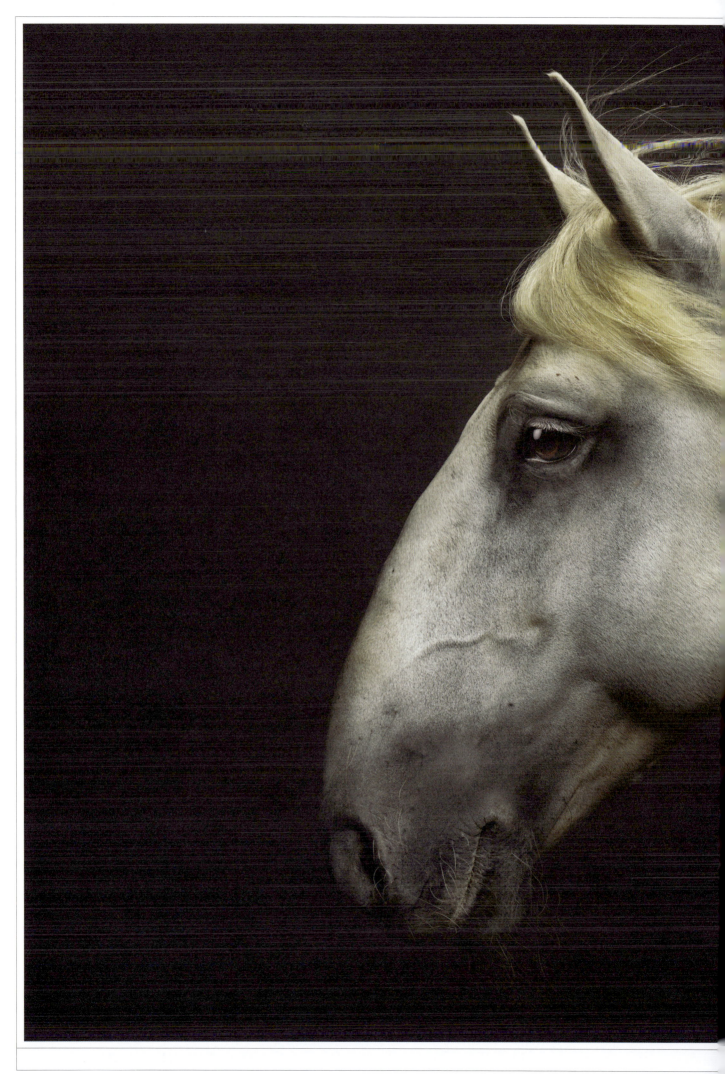

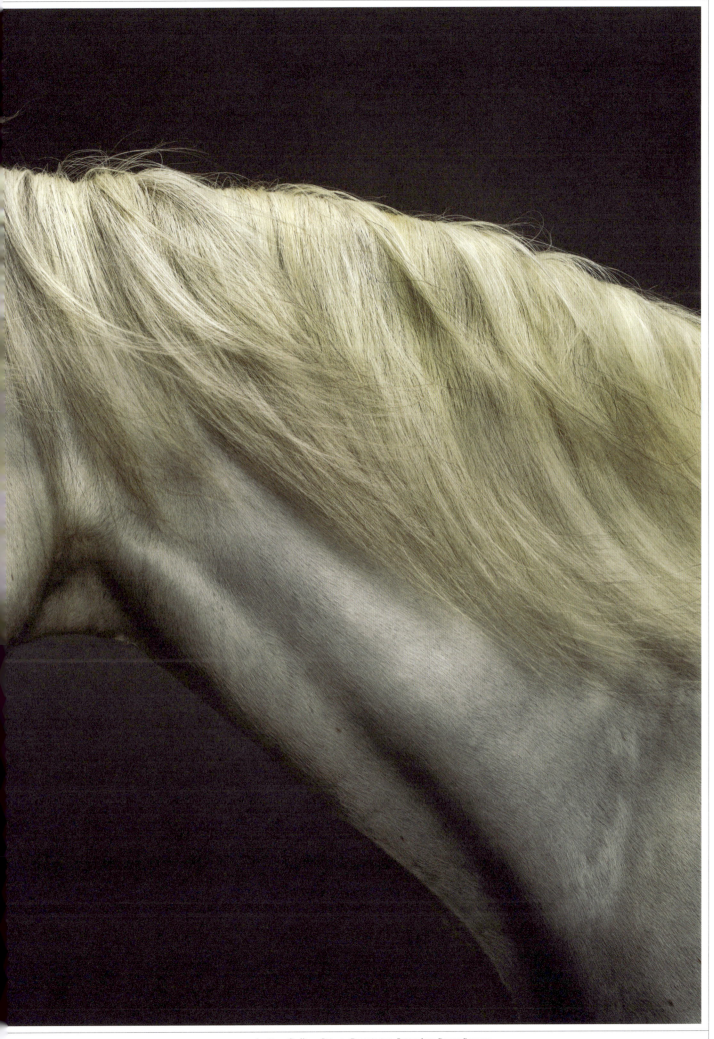

Lusitano Stallion, Private Commission. Retoucher: Stacey Ransom

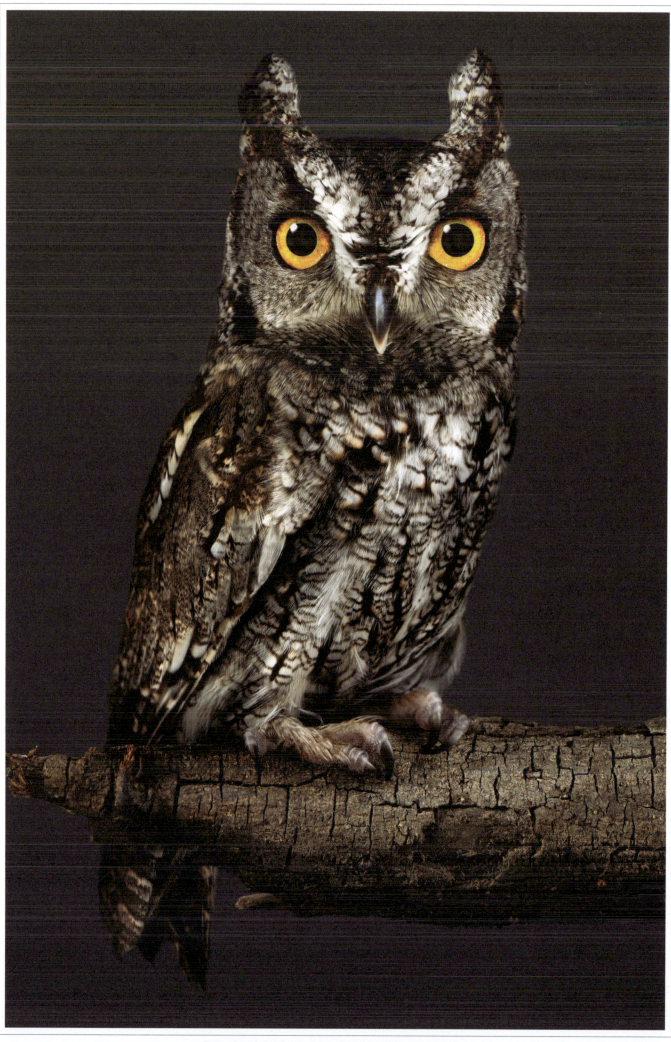
Western Screech Owl, Storybook Animals Series. Retoucher: Stacey Ransom

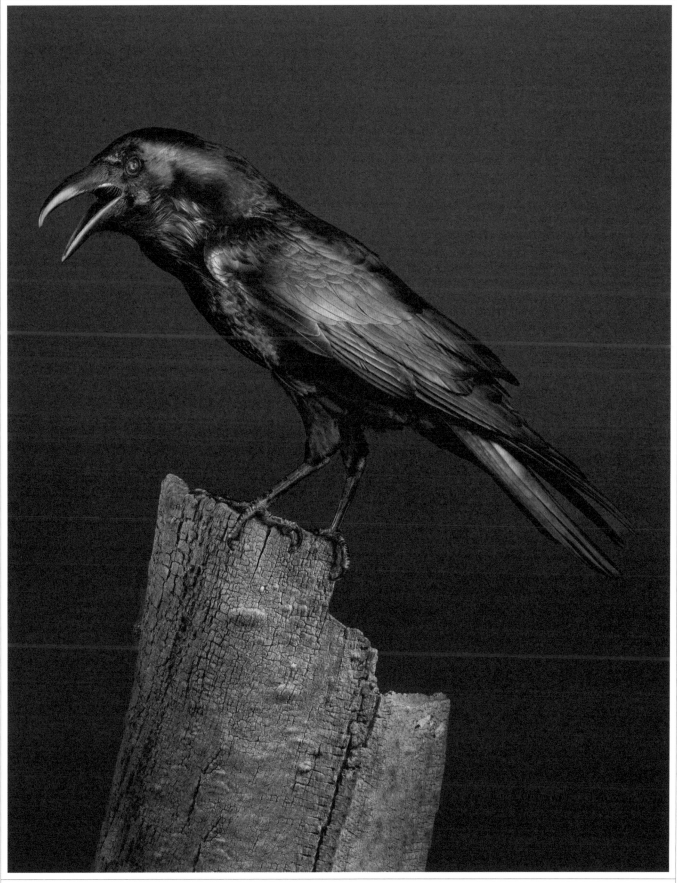

Raven, Storybook Animals Series. Retoucher: Stacey Ransom

Howard Schatz: Everything is Inspiring

HOWARD SCHATZ'S WORK IS INVENTIVE AND EXTREMELY BEAUTIFUL. THE BEST COMPLIMENT I CAN GIVE HOWARD IS THAT I AM JEALOUS OF THE PICTURES HE MAKES.
Robert Longo, *Artist*

HE HAS AFFECTION FOR HIS SUBJECTS, WHICH SHOWS IN EVERY REMARKABLE IMAGE. SOMETIMES FUNNY, OFTEN DRAMATIC, HE IS A MASTER OF BOTH THE QUIET, REVEALING PORTRAIT AND THE EXPLOSIVE SURPRISE.
Graydon Carter, *Former Editor-in-Chief, Vanity Fair*

BEING PHOTOGRAPHED BY HOWARD IS LIKE TAKING A WILD RIDE ONLY TO DISCOVER YOU'VE LOST YOUR BRAKES. I HIGHLY RECOMMEND IT.
Jeff Daniels, *Actor*

HOWARD'S OUTPUT IS NOTHING SHORT OF ASTONISHING, NOT ONLY A MILE WIDE BUT A MILE DEEP. THERE IS SIMPLY NO ONE MORE VISUALLY INTELLIGENT, ADVENTUROUS, AND INDEFATIGABLE.
Owen Edwards, *Writer & Photography Critic*

BEING INTERVIEWED BY HOWARD IS AN INTIMATE AND WONDERFUL EXPERIENCE. IDEAS OF ONE'S SELF DROP AWAY AS YOU ENGAGE WITH HIM IN HIS PROCESS OF PHOTOGRAPHING WHAT FEELS LIKE ONE'S INSIDES AS MUCH AS THE OUTER LAYERS.
Melissa Leo, *Actress*

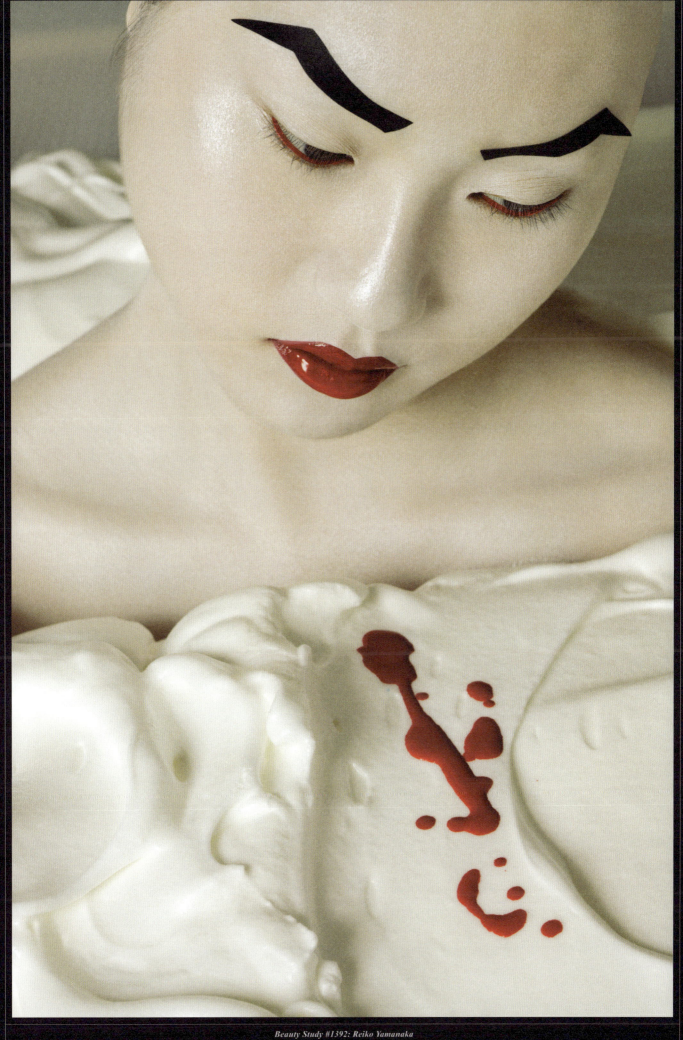

Beauty Study #1392: Reiko Yamanaka

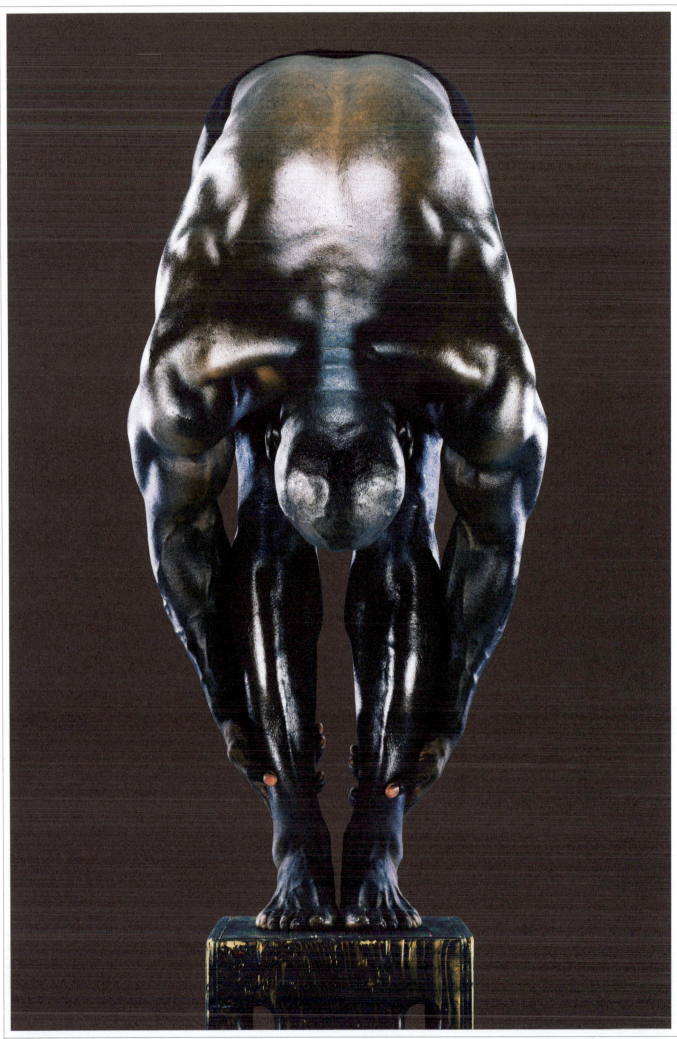

Human Body Study #1320: Bryan Scott

Introduction by **Ariel Orr Jordan** *Playwright*

Howard Schatz's photographs are nothing short of a visual poetic essay that explores and celebrates the endlessly fascinating variations of the human body and relationships. The captivating imagery within speaks volumes—it's soulful, electrifying, and truly hypnotic. In every single image, Howard manages to capture the essence of multifaceted complexity, turning each into a work of art that leaves a lasting impact. There's an undeniable divine spark in Howard Schatz's photographs, and his photographic prowess is nothing short of an innovating tour de force on the cutting edge of contemporary photography.

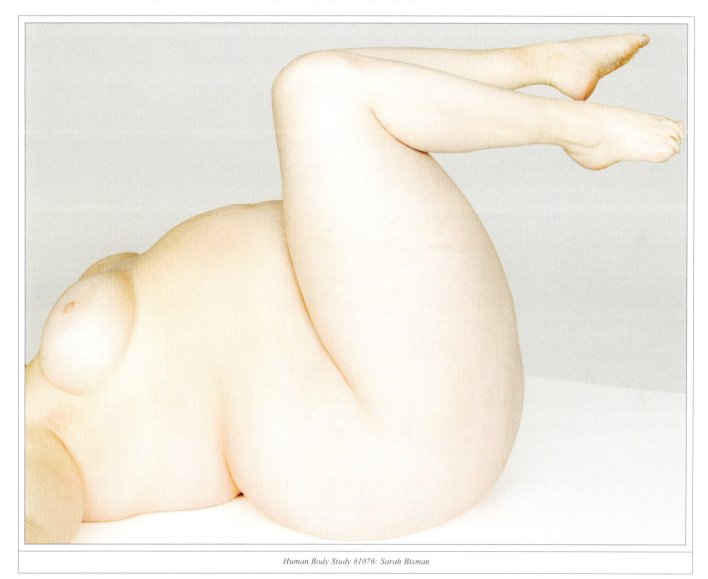

Human Body Study #1076: Sarah Bisman

GOD PLACED A MAGICAL CAMERA IN HOWARD SCHATZ'S BRAIN AT BIRTH, GIVING HIM THE ABILITY TO HEAR WITH HIS EYES AND SEE INTO THE HUMAN HEART. HIS PHOTOGRAPHS CAPTURE ALL THE ENERGY OF LIFE, TRANSCENDING GRAVITY AND TIME WITH WIT AND GRACE.

John Guare, *Playwright*

Q&A: Howard Schatz

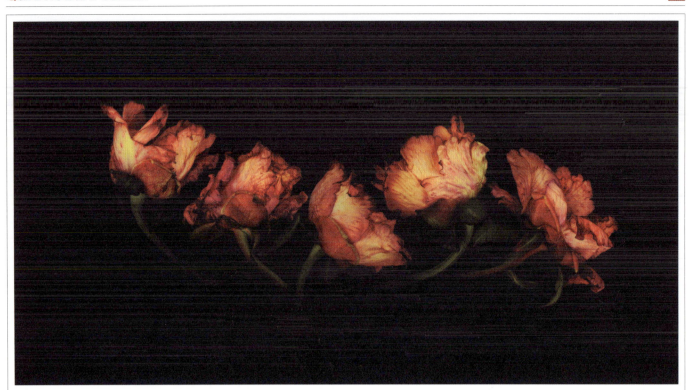

Five Common Peony, from the book "Botanica"

What has inspired or motivated you in your career?
I have a deep, passionate attraction to visual imagery; creating photographs brings me great satisfaction. I enjoy looking at all kinds of images: photographs, painting, graphic design, sculpture, architecture, etc.

What is your work philosophy?
I make images to surprise and delight myself. It is not helpful to think about, worry about, or be concerned with what others might think. The images I make must satisfy me before I let them out into the world.

Who is or was your greatest mentor?
I have had many great teachers throughout my career. Those who had the most significant impression on me were those who sought to see things that were original, new, revealing, thrilling, and inspiring.

What is the most difficult challenge you've overcome to reach your current position?
I am at the point in my experience and career where I can take a reasonably good photograph almost all the time—the challenge is making something truly unique and fantastic. That is extremely hard; no matter how hard I work, it is still fleeting. Sometimes, all the elements combine to create something remarkable and spectacular. I don't always have control over that end, but by working hard at it constantly and sticking with it, magnificence visits me every so often.

Who have some of your greatest past influences been?
Everything has the potential to inspire. It is important to be open, to see the world anew and hopeful, knowing there is always a chance for some spark to come from my experiences and observations. Paying close attention is helpful.

Who among your contemporaries today do you most admire?
I am so impressed by how many great visionary, accomplished, and skilled photographers there are. It seems that I discover someone new every day. I follow many leads, look at many websites, read books, magazines, social media, etc. I pay attention and know that as I remain open and keep looking, I will find brilliant people doing wonderful work.

What would be your dream assignment?
I make images for myself, and so the assignments are my own. I am as hungry as ever to create and discover new and exciting imagery that comes from within me.

What do you consider your most outstanding professional achievement so far?
I am constantly moving. I strive to make images that are new to me, that shock me, and that feel richly satisfying. Then, I move on, maintaining a course of exploration, experimentation, and occasionally satisfying results.

What about your work gives you the greatest satisfaction?
Essentially, I am on a moving track of searching, experimenting, and exploring to find and create imagery that excites, surprises, and delights me.

Howard Schatz www.howardschatz.com
See his Graphis Master Portfolio at graphis.com.

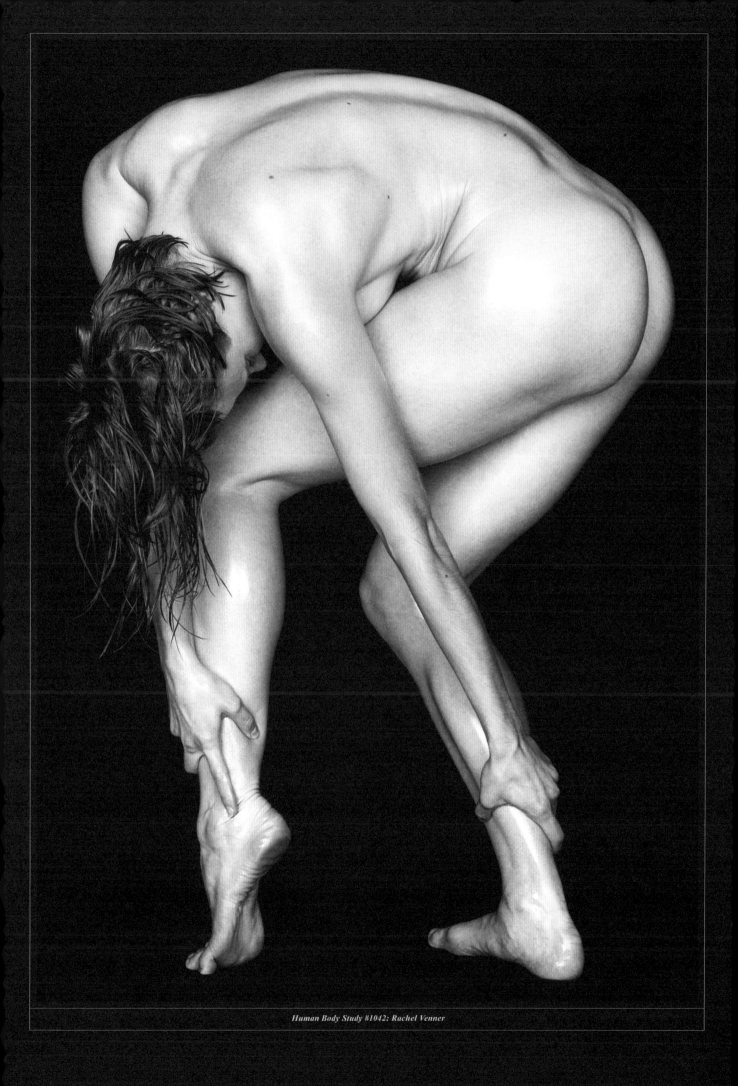

Human Body Study #1042: Rachel Venner

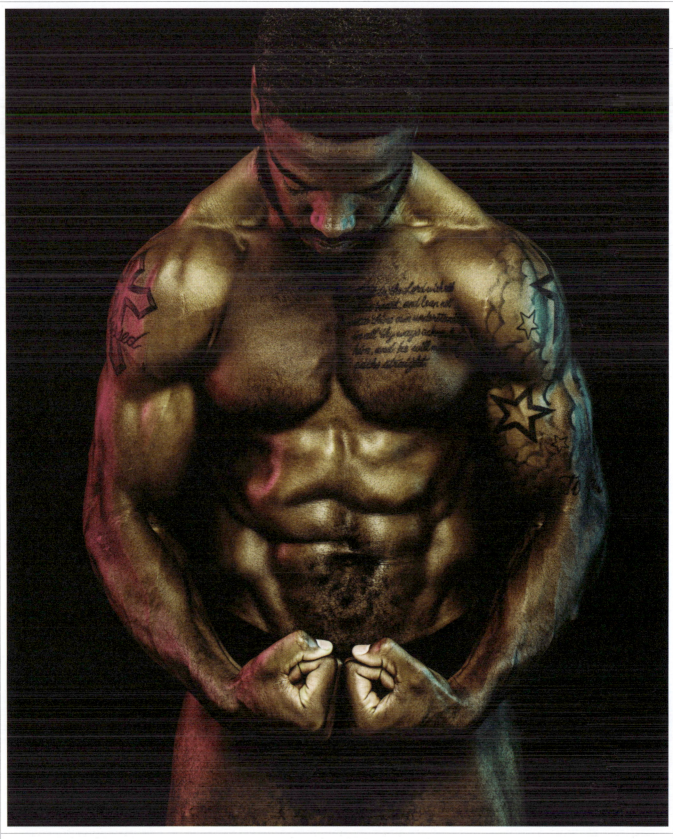

Jeremy Chinn, NFL Safety, #3

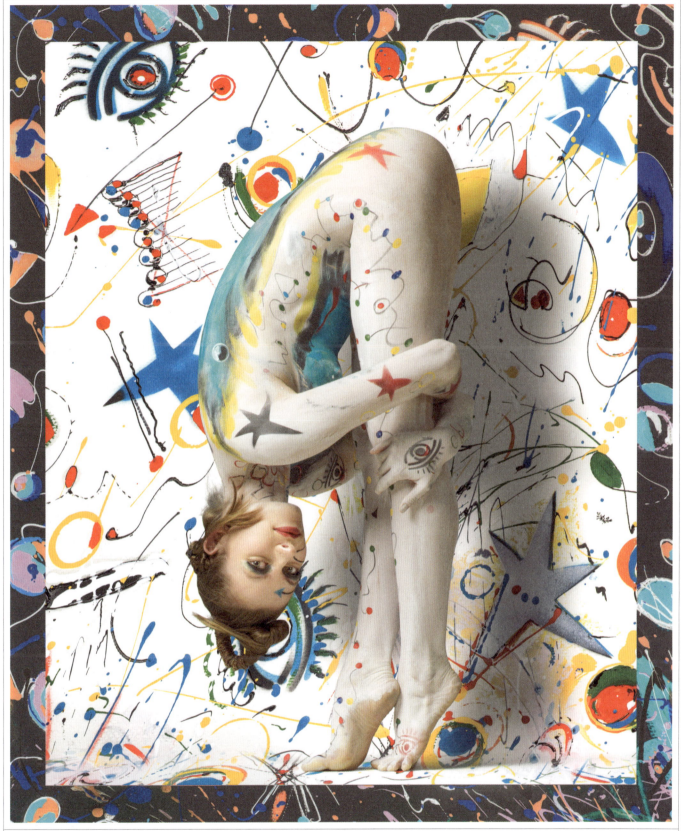

Abby DeReamer, #1568. Dancer/Model; Body painting (Silvia Pichler) and design inspired by Miro.

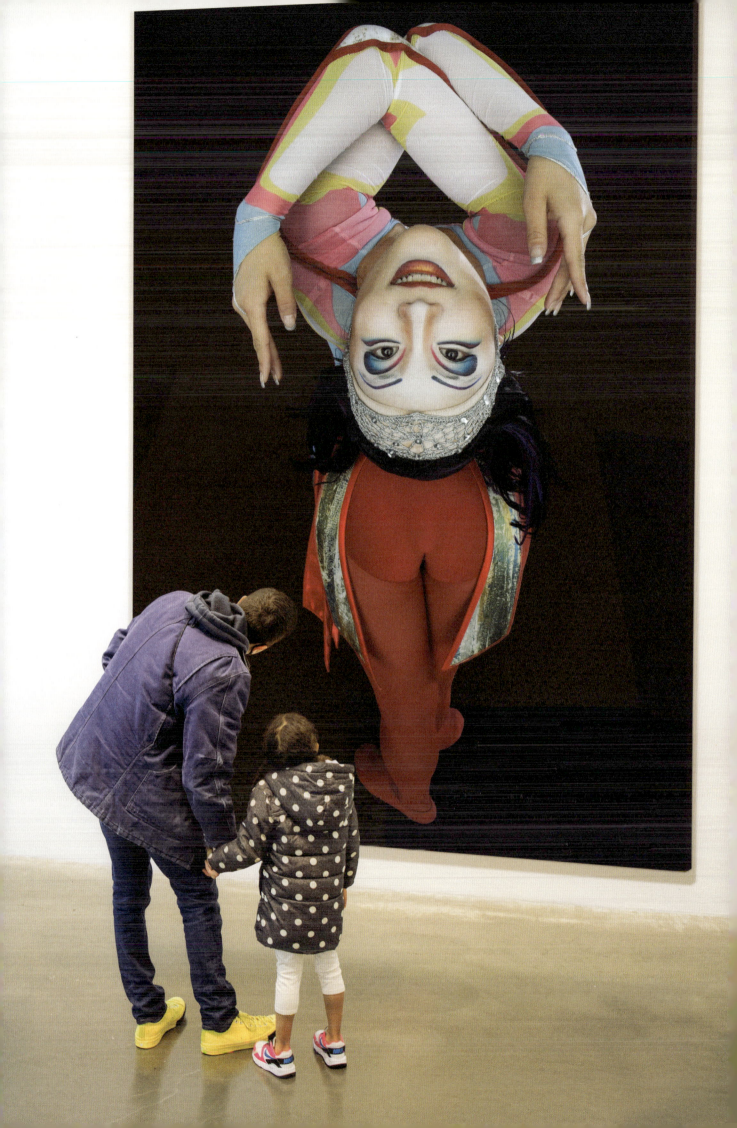

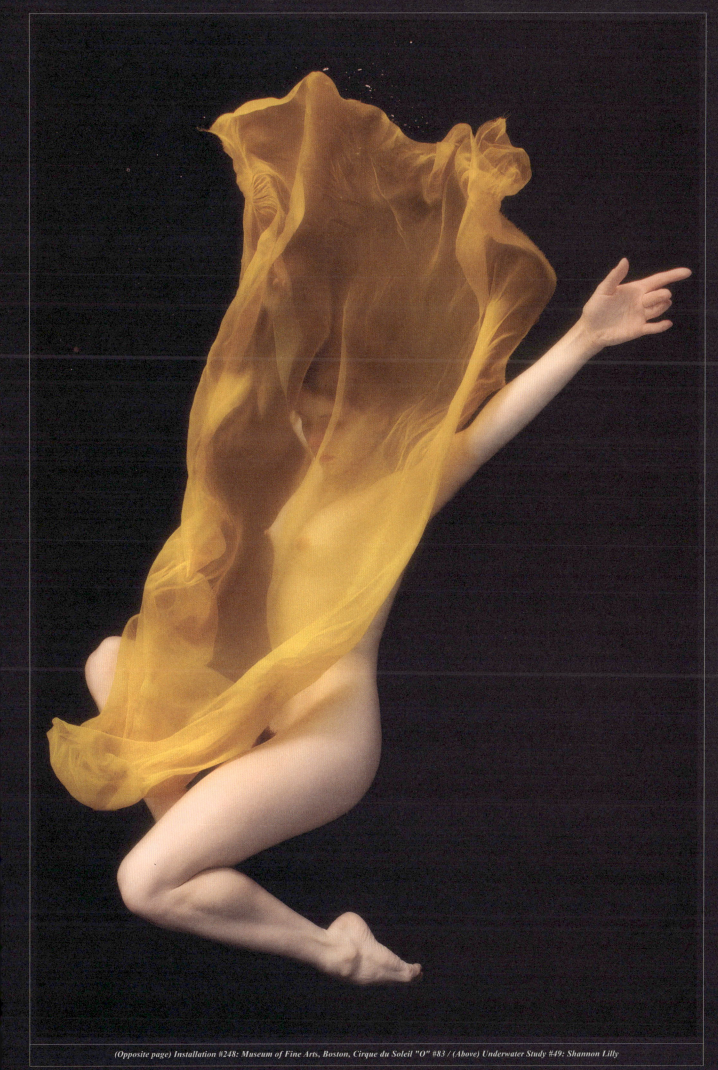

(Opposite page) Installation #248: Museum of Fine Arts, Boston, Cirque du Soleil "O" #83 / (Above) Underwater Study #49: Shannon Lilly

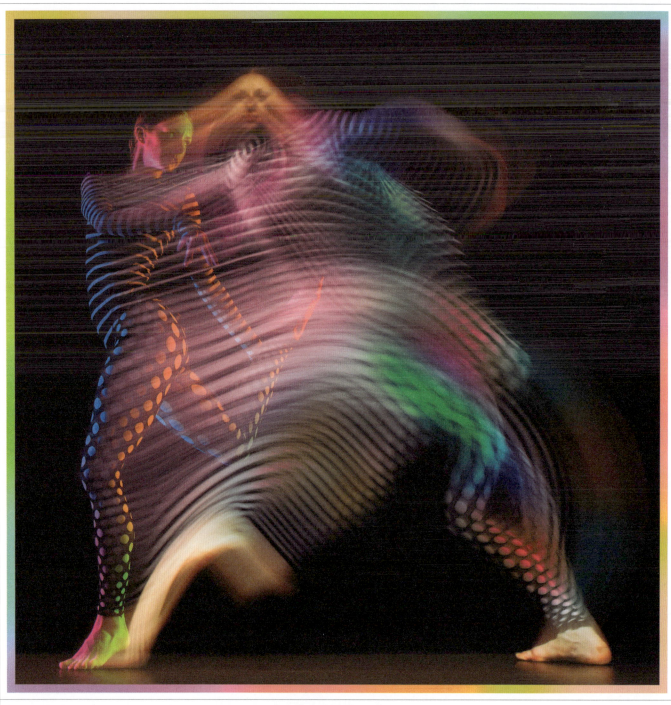
Dance Study #1441: Victoria Sames

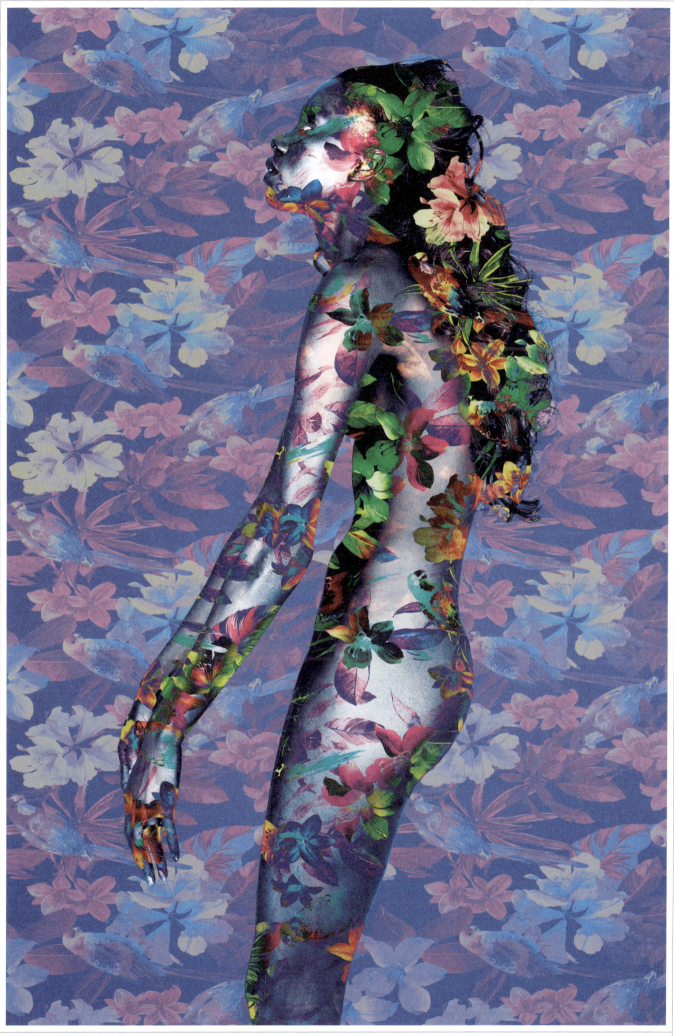
Beauty Study #1460: Sigail Currie

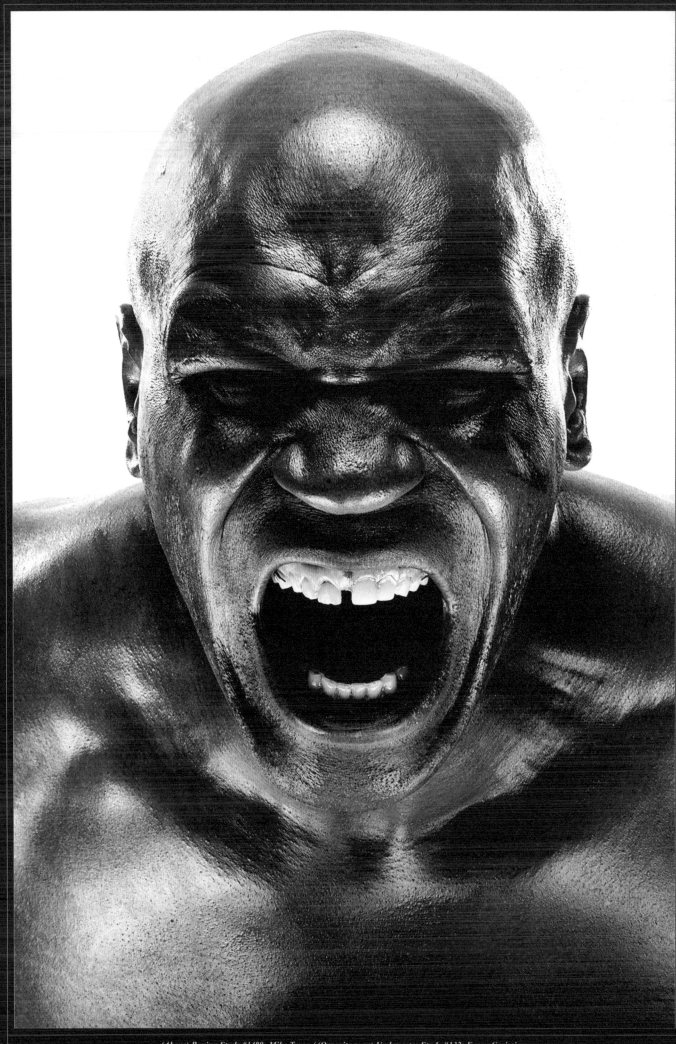

(Above) Boxing Study #1489: Mike Tyson / (Opposite page) Underwater Study #132: Karen Carissimo

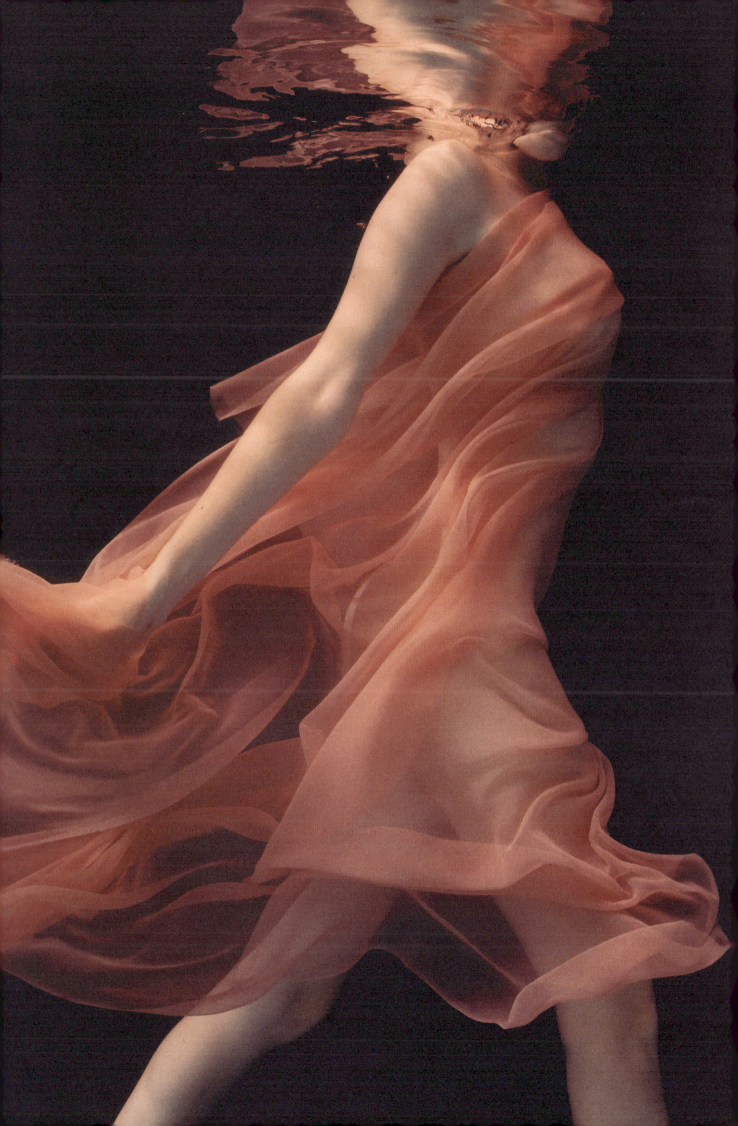

A

ART/ILLUSTRATION

96 GUY BILLOUT / FRANCE & USA

Guy Billout: A Product of Enjoyment

GUY'S BRILLIANT CONCEPTUAL ILLUSTRATIONS NEVER FAIL TO CAPTIVATE, BRINGING A SMILE WITH EACH ENCOUNTER. HE STANDS AS A TRUE LEGEND IN THE WORLD OF ILLUSTRATION.

Von Glitschka, *Creative Director, Glitschka Studios*

GUY IS ONE OF THE FINEST ILLUSTRATORS OF OUR DAY. HE IS TOTALLY ORIGINAL AND A TRUE HEIR TO HERGÉ, HOKUSAI, AND OTHERS.

Nancy Hoffmann, *Freelance Copywriter, NancyWritesCopy*

GUY BILLOUT IS A LODESTAR FOR CREATING INTELLIGENT, HUMOROUS, AND CHALLENGING WORK. THERE IS ALWAYS, AND I MEAN ALWAYS, AN UNEXPECTED ELEMENT IN HIS ART THAT MAKES ME LOOK TWICE OR SEVEN TIMES.

MAY HE CONTINUE TO CHALLENGE AND INFLUENCE ILLUSTRATORS WITH HIS FIERCELY QUIET, SUBVERSIVE HUMOR AND INTELLIGENCE.

Rick Sealock, *Professor, Sheridan College*

GUY BILLOUT IS A UNIQUE ARTIST WHOSE SIMPLY SURREAL VISUALS ON IMPOSSIBLE SITUATIONS MAKE ONE LOOK MORE THAN TWICE TO "ABSORB" THE PROFOUND BEAUTY OF HIS INNOVATIONS.

Barbara Nessim, *Illustrator & Artist*

(Page 95) For BMC Software, Inc., Annual Report 1992 / (Above) For Salomon Brothers Corporate Brochure, Designed by PA Consulting Group, 1998

Introduction by **Timothy Cain** *Artist & Illustrator*

How do you introduce an icon who needs no introduction? A man who can tell a complete story without words? In a world of visual overload, Guy Billout pushes "pause" with a child's pen and a higher power's intellect. Few artists possess his innate competence to unfold mysteries in one simple "Aha!" moment. Guy's x-ray brilliance peers around the corner and beneath the surface into what's hidden in plain sight. And we want more. Part seer, part seeker, and part sage, his nuance is his genius, his wonder our delight. Like Escher with wings, the concept is complete, clever, and unimaginably its own. Often imitated, never reproduced, there could be a Guy Billout Award for the quickest "draws" in conceptual creativity. Enter in…

For LG Corporate Brochure, 1996

Q&A: Guy Billout

You were last featured in issue #356 of the Graphis Journal. How have things been for you since then? What has changed, and what has stayed the same?
What has changed is realizing my need to please; even when granted total freedom, deep down, I am aware of my readers' expectations. Only in my personal sketchbooks do I feel that no one is looking over my shoulder to see what I am doing. What hasn't changed is my procrastination. Without the assignments' deadlines, I would be "on the moon," as my mother would say.

What has inspired or motivated you over the course of your career as an illustrator?
I can identify a few apparent influences in my work, but so many sources inspire me in unpredictable ways. It is a platitude to say it, but I feel I am the product of all the paintings, movies, books, plays, music, and architecture I enjoy.

What is your work philosophy?
Draw what you really enjoy drawing.

Who is or was your greatest mentor?
I wish I had what I understand as a mentor, i.e., a physical person assisting me step by step. However, I will mention an art teacher I met when I was 12. His name was René Lacote, and he was leading a workshop outside the school system. There were no restrictions in his class, and this, I believe, helped me develop an artistic assertiveness that proved crucial when I became an illustrator.

"Erosion" for The Atlantic, June 1994. Art Director: Judy Garlan

Q&A: Guy Billout

Who among your contemporaries today do you most admire?
I have a long list of contemporaries I admire; out of this list, I single out Christoph Niemann because he embodies the principles that have inspired me since I started working as a graphic designer in advertising: good ideas, easy to understand, and well-executed. Christoph comes up with exquisite, intelligent concepts doubled with a keen sense of humor. His graphic virtuosity and an uncanny ability to reinvent himself with various stylistic approaches make him peerless.

Who have been some of your favorite colleagues or clients?
I am grateful for the first professional persons I met shortly after arriving in New York in 1969: Bob Ciano, art director at *Redbook* magazine, and Kit Hinrichs, graphic designer at Russell & Hinrichs. Both trusted me with my very first assignments. It was more remarkable since I had never been published as an illustrator. We immediately related, despite my very limited English, and many years later, I remain in touch with these generous and talented friends.

At about the same time, I met Milton Glaser, who was already a hero of mine back in Paris. As the art director of the *New York* magazine, he published all 13 biographical drawings that composed the illustration portfolio I had improvised before coming to New York. Étienne Delessert, an outstanding children's book author and illustrator, was instrumental in helping me navigate my new world and introducing me to Harlin Quist, the publisher of Étienne's pioneering stories with Eugène Ionesco and of my first children's book.

Another extraordinary encounter occurred in 1982 when Judy Garlan, the art director of *The Atlantic*, gave me the most unusual assignment by granting me total editorial freedom for a full-page illustration in color. That became a regular feature that lasted 24 years. I owe a great deal to her because her assignment allowed me to break new ground; free of any theme or text written by someone else, I had to rely on my most intimate resources for inspiration. This generated some images with an emotional and poetic charge that I've seldom attained in regular assignments, even in my children's books.

What are the top things you need from a client to do successful work for them?
Mostly to give me carte blanche.

How did you develop your illustration style?
Style has always been the least of my concerns. As a student, I never looked for a style; I just drew.

What tools do you use to make your illustrations?
At the beginning of my career, I used Dr. Ph. Martin's dyes with a brush until I discovered the airbrush in the 70s. Most of my physical work was done with this technique. With the advent of the computer, my illustrations gradually became digital, although I always draw with a pen on paper before coloring with Photoshop.

Your illustrations have been featured in numerous publications and periodicals. Is there a publication you enjoyed working with the most? What have been your favorite work assignments?
By far, the regular feature commissioned by Judy Garlan for *The Atlantic*.

You have also illustrated seven children's books. What is the process like, and which book is your favorite?
Perhaps the best answer to this question is my first and favorite children's book, *Number 24*, by Harlin Quist. I was still a beginner when Harlin approached me with the proposal: "Do a book—whatever you like." To my surprise, I had none of the anxiety that usually visited me, even with the most modest assignment. I retired to a motel room for two months and created the story of a boy imagining all sorts of catastrophes happening to all kinds of vehicles while waiting for the school bus. When the bus arrives, nothing happens, and the boy has to go to school. The wordless story poured out of me with remarkable ease. It was the first hint of my aptitude as an author.

What about your work gives you the greatest satisfaction?
When I complete an image that surprises me. By contrast, I keep a box I call the "Box of Horrors" for images I bungled. In some cases, the reasons for failing are as enigmatic as succeeding.

What professional goals have you reached, and what goals do you still have for yourself?
I am not sure I ever had precise professional goals. If the way I became an illustrator is a good example, I seem to rely on improvisation and adapting to circumstances. Today, I have lost the drive to work on stories written by others and, to some extent, to write my own stories for children's books, but I would love to write and illustrate a graphic novel. Teaching also still gives me a sense of purpose.

What would you change if you had to do it all over again?
Nothing. I still marvel at how things turned out since I arrived in New York.

Who are the rising stars of illustration?
There was a time when I closely watched the work of the best illustrators. I devoured Graphis long before I became an illustrator. I am now more interested in other fields, like comic strips and the great painters.

How do you balance your work with your personal life if there is a distinction between the two for you?
The American language has a good word that applies to me: workaholic. There is an exception to my devotion to assignments; over the years, I have created birthday cards, Valentine cards, etc. for my wife, Linda. This allows me to indulge in a genre I really love but seldom practice: cartoons.

In what ways do you see your field changing over the years?
It may be irrelevant today to evoke the way it was when I arrived in this country. In 1969, every art director I called made a point to meet me in person, without exception. I also saw the slow erosion of the power of art directors to the benefit of people of the text, like editors, not to mention the shrinking of budgets. But illustration continues. I remain amazed by the quality of what I see in professional publications, though not in magazines.

Guy Billout
See his Graphis Master Portfolio at graphis.com.

"Choices" for Micom Systems, Inc., Annual Report 1986

"Deus Ex Machina" for The Atlantic, May 1999. Art Director: Judy Garlan

"Phobia" for The Atlantic, August 1983. Art Director: Judy Garlan

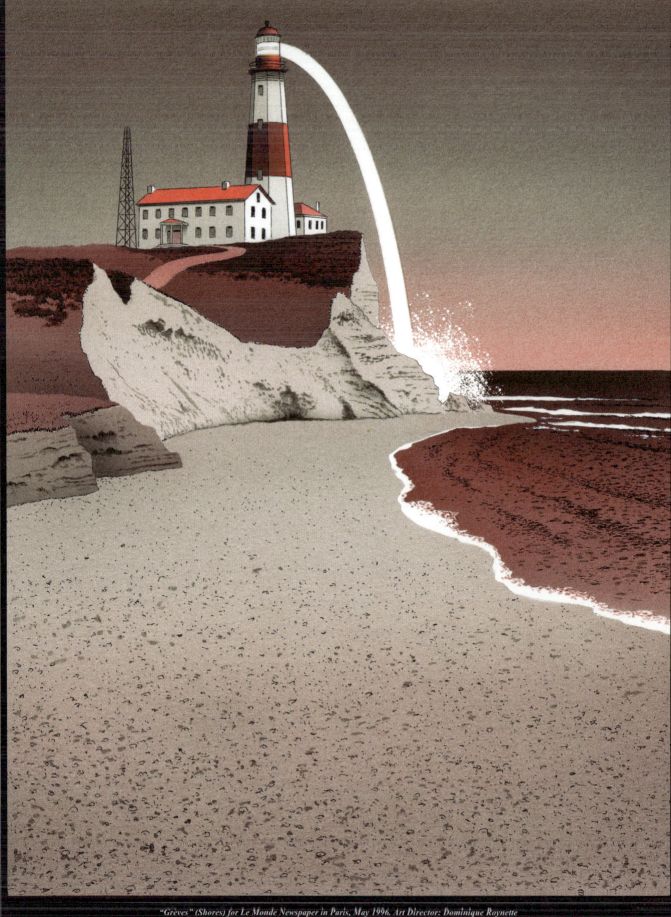

"Grèves" (Shores) for Le Monde Newspaper in Paris, May 1996. Art Director: Dominique Roynette

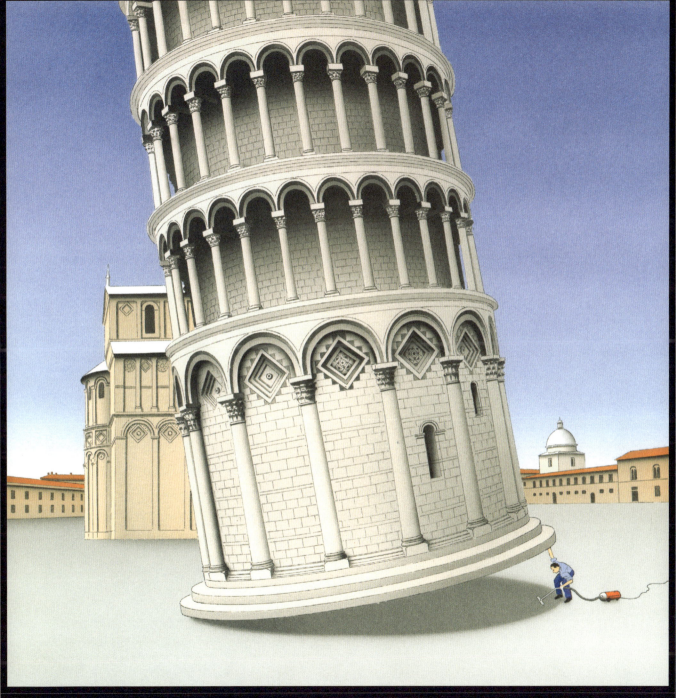

For a story about Italy having to clean up her act to meet the Maastricht's standards for Time Magazine UK, about 1990. Art Director: Paul Lussier

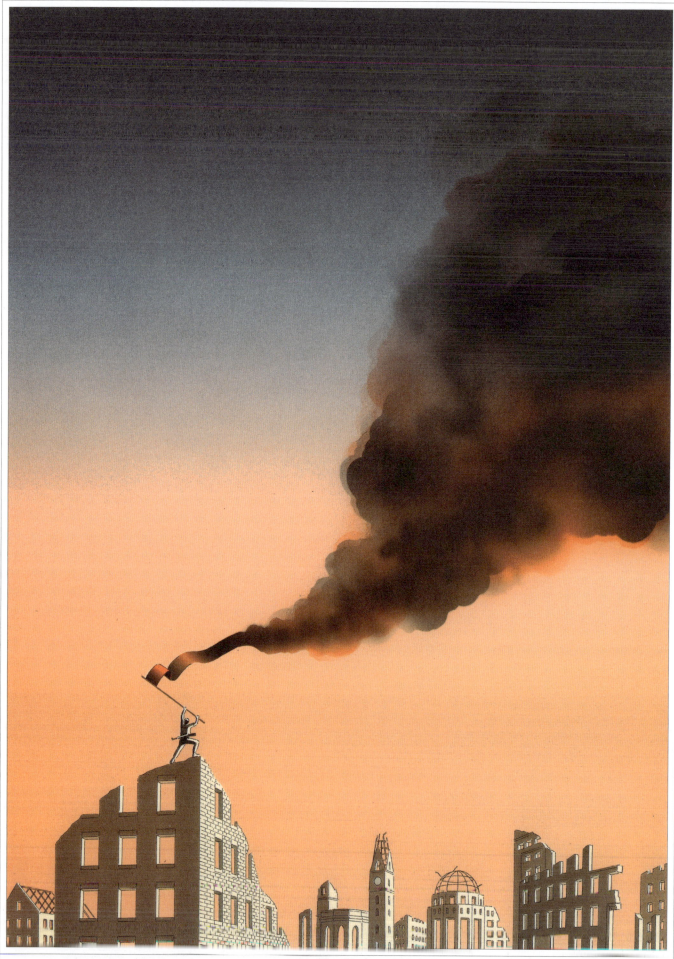

For a story entitled "The Master Plan" for The New Yorker Magazine, September 2016. Art Director: Chris Curry

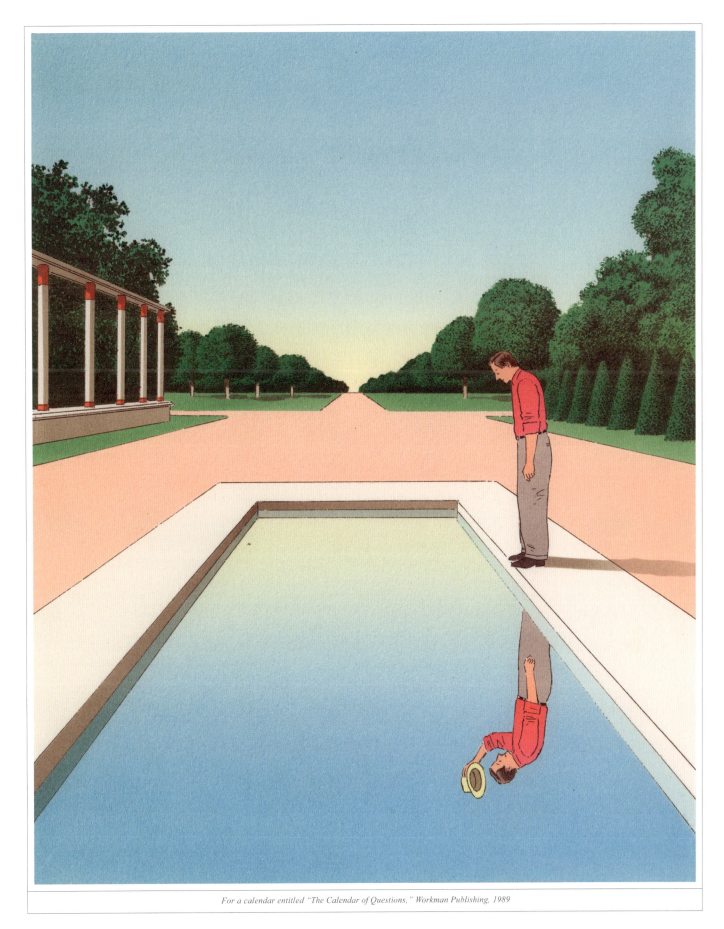

For a calendar entitled "The Calendar of Questions," Workman Publishing, 1989

GUY BILLOUT'S IMAGINATION AND
VISUAL SENSE OF HUMOR IS ENDLESS,
AND ALL BRILLIANTLY EXECUTED.

B. Martin Pedersen, *Designer*

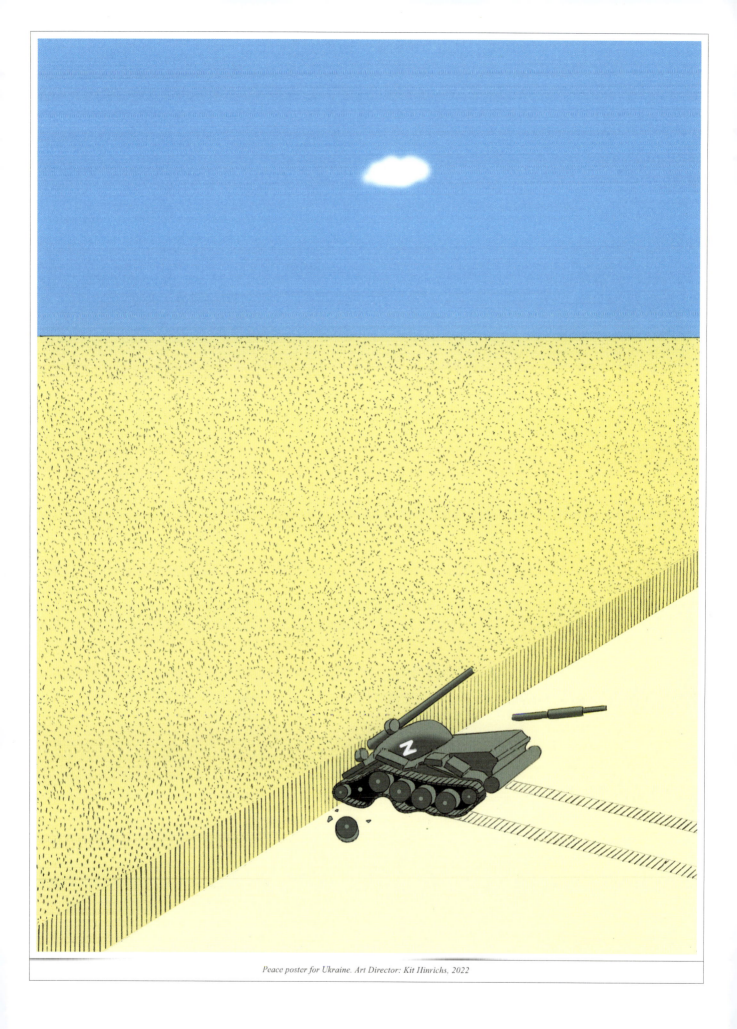
Peace poster for Ukraine. Art Director: Kit Hinrichs, 2022

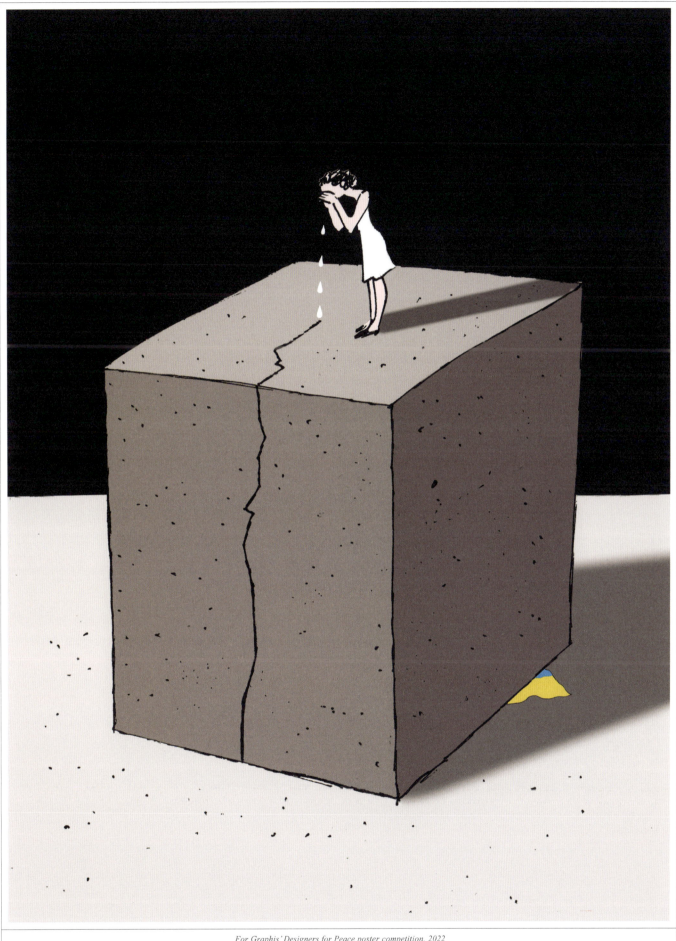

For Graphis' Designers for Peace poster competition, 2022

P

PRODUCT

112 GHOST BY ROLLS-ROYCE / UK

114 FETCH+ 4 BY TREK / USA

116 TWIN-ENGINE DA62 BY DIAMOND AIRCRAFT

118 TAURUS ELECTRO BY PIPISTREL / SLOVENIA

GHOST BY ROLLS-ROYCE **$400K**

Length: 218.3 in (5,545 mm) **Height:** 61.9 in (1,572 mm) **Weight:** 5,490 lbs (2,490 kg) **Power output/engine speed:**
Width: 84.6 in (2,148 mm) **Wheelbase:** 129.7 in (3,295 mm) **Engine:** V/12/48 563bhp/420kW/571 PS (DIN) @5,000 rpm

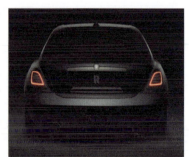

With the latest iteration of the Ghost, Rolls-Royce has continued to uphold a spirit of customizability. In 2019, Bloomberg reported that over 90% of sold Rolls-Royce cars are so customized that they can essentially be considered one-offs. In the following five years, the automobile company has maintained this dedication to customizability, with the second generation of the Ghost being no exception. Rolls-Royce even describes the car as a blank canvas for customers to transform.

In the interest of brevity, the sheer breadth of customization on offer can be quickly understood with two aspects of the vehicle. The first aspect is the interior roof of the Ghost, which features a mode that shows a starscape, with the customer free to request any constellation they wish to be featured. The second aspect is the included umbrella, which can be purchased with over 20 different color options for its canopy, handle, and beads.

The umbrellas, which are concealed within the vehicle's doors, are just one of two components carried over from the first generation of the Ghost, with the other being the Spirit of Ecstasy mascot on the hood. Every other aspect was redesigned from the ground up, with those who worked on the vehicle aiming to maintain the appearance and essence of the original model. Such a bold redevelopment speaks volumes of the boldness of those who worked on the new model, especially as the original generation of Ghost soon became Rolls-Royce's most successful car of all time. The temptation to maintain the status quo must have been enormous. Instead, the

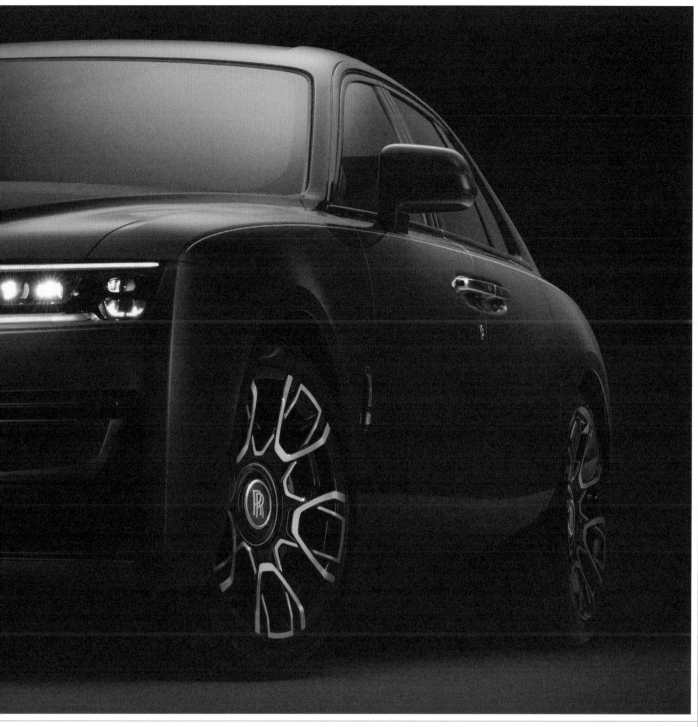

Rolls-Royce

Max torque @ engine speed:	Fuel type: 10:1/Premium unleaded	Fuel consumption (combined):	CO2 emissions (combined): 343 g/km
850 Nm @ 1,750 rpm	Acceleration: 0-62 mph (0-100 km/h) 4.8 seconds	18.8 mpg/15.0 ltr/100km	

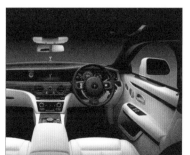

creative team decided to reinterpret almost every aspect of the original Ghost.

Possibly the most impressive design element that has been carried over from the earlier Ghost to the new version is the ethos of offering luxury through minimalism. The specific term that designers at Rolls-Royce use is "post-opulence." At the start of the redevelopment, the company realized that its customers were eager for an understated Rolls-Royce, and so the designers set about "post-opulencing" every aspect of the Ghost. This extends to much more than just the physical materials and angles of the vehicle. For instance, the interior of the car is completely soundproof, so much so that Rolls-Royce engineers had to add a slight whisper sound to eliminate the strange sensation that complete silence left on those who sat inside.

This near silence also demonstrates how the essence of the forefather of the Ghost, the Rolls-Royce Silver Ghost, can clearly be felt in this latest iteration. The Silver Ghost, which was in production exactly 100 years ago, was named due to its then astoundingly quiet engine. Numerous media outlets named it as the best car in the world at the time, and as chief executive officer Torsten Müller-Ötvös has stated, "The Silver Ghost's unequaled marriage of performance, strength, reliability, technological innovation, driver engagement, and comfort provides a template for everything we do more than a century later." Anyone who has been lucky enough to experience either generation of the Ghost is sure to agree.

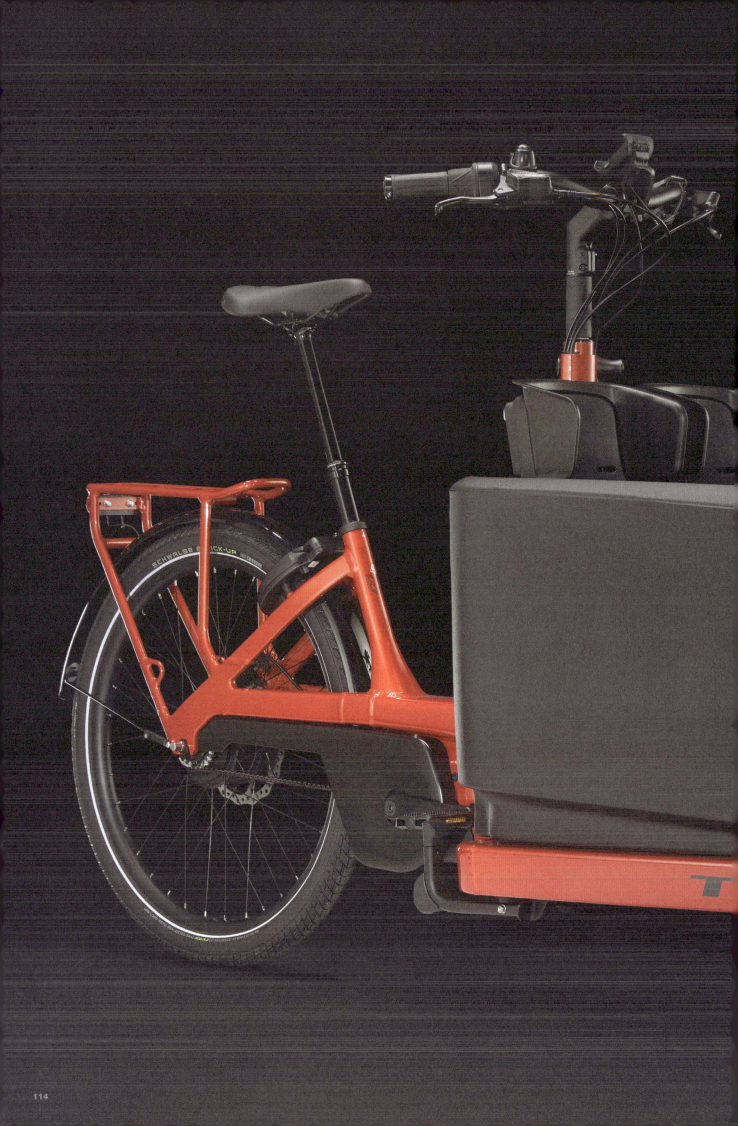

FETCH+ 4 BY TREK $8,500

The Fetch+ 4 may be the oddest-looking bike since the penny-farthing. The cargo box that stretches past the handlebars is so distracting that it takes some time to realize that its wheels, much like the penny-farthing, are different sizes. Luckily, this e-bike is much more practical than its Victorian ancestor, with the ability to carry five children in addition to the rider being a major design achievement.

The appearance of the Fetch+ 4 is undoubtedly idiosyncratic. At first, some may even consider it to be ugly. That's the issue with bold new approaches: They take time to be accepted. After all, one of the world's most iconic office chairs, the Aeron chair, was originally rejected by industry experts and customers alike just because it looked unusual. The Fetch+ 4 conveys a similar energy. Yes, the "snout" of the bike does initially look odd. But the solidity of the product also conveys that this is an efficient, sturdy design that's enjoyable to ride. Eventually, most will come around to the Fetch+ 4's charms. Even those who are unable to connect with it aesthetically must concede that the design is both innovative and highly practical.

Trek, the organization behind the Fetch+ 4, may be overstretching a little when it claims that the bike can "even replace your car." That may be an option for a certain demographic, such as those who live in urban environments. Yet it would be surprising if many people actually decided to ditch their SUVs and sedans in favor of using an electronic bike. However, the Fetch+ 4 still has plenty to offer those who may want to use it as something other than a primary mode of transportation. For instance, the box's ability to carry up to 175 lbs, with the bike's overall weight limit being 551 lbs, should certainly appeal to the weekend warrior who wants to bring equipment with them on their next adventure.

The biggest testament to the Fetch+ 4's design is its maneuverability. Some have even stated that it feels almost as if it's turning itself. This advantage is sure to impress anyone who initially misjudged the bike as being cumbersome. To misquote a famous phrase, don't judge a bike by its cargo box!

Frame: High-performance hydroformed alloy, low-step, removable integrated battery, internal cable routing, motor armor, post-mount disc, 148x12 thru axle.
Fork: SR Suntour Mobie, 2 in (50 mm) travel
Wheel front: Formula DC-71 sealed bearing, 6-bolt, 0.5x4 in (15x100 mm) thru axle hub, 32-hole, 1.2 in (30 mm) width rim.
Wheel rear: Enviolo CVP HeavyDuty, 40T spline, 6-bolt, solid axle, 36-hole, 1.2 in (30 mm) width rim.
Battery: Bosch Power Tube 75Wh, smart system
Motor: Bosch Performance Line Cargo, smart system, magnesium motor body, 85 Nm
Weight: 165.35 lbs (75 kg)
Combined weight limit: 551 lbs (250 kg)
Max speed: 20 mph
Range: 86 miles

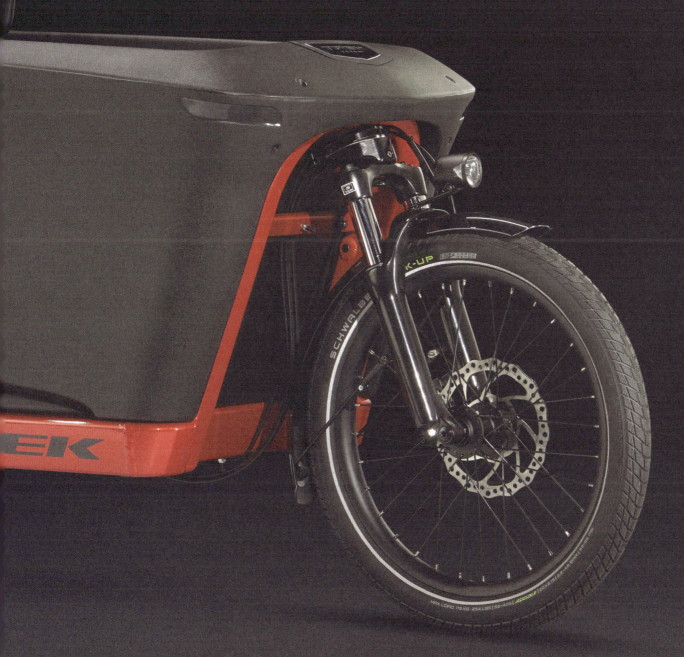

TWIN-ENGINE DA62 BY DIAMOND AIRCRAFT $1.5M

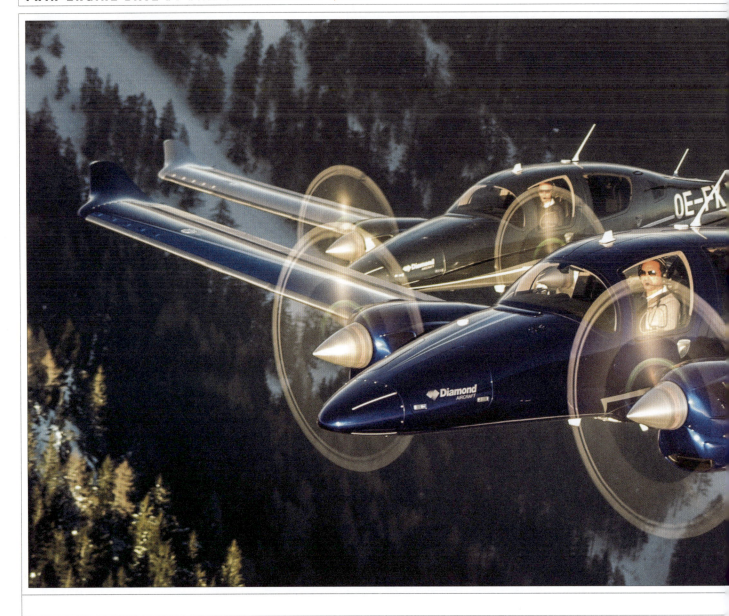

Engine: 2x Austro Engine AE330 turbocharged common-rail injected 2.0 liter jet fuel engine with 180 HP and EECU single lever control system
Max speed at 14,000 ft: 192 kts TAS (221 mph/356 km/h TAS)
Cruise speed at 85%: 180 kts TAS (207 mph/333 km/h TAS)
Max rate of climb: (MSL) 1,028 ft/min (5.2 m/s)
Max range (incl. auxiliary tank) (FL160, 50% PWR)

The preselected color schemes of the DA62 perfectly complement each aircraft. And the gleaming metallic finishes enhance these tones, which have suitably luxurious-sounding names, including Ruby Red, San Marino Blue, and Champagne Gold. There is also the option to order a model with a custom color tone, but Diamond Aircraft has undoubtedly put significant thought into the colors that best give each plane the vibrancy of a 1950s Cadillac. Essentially, who would want to deviate from these company-approved tones that effortlessly complement the overall design?

With the plane having such a bold outward appearance, it comes as quite a shock to see that the interior has the feel of, as Diamond Aircraft states, a "flying luxury SUV." A vintage car-like exterior combined with a people carrier-like interior sounds like a vehicle that would clash terribly. Somehow, the DA62 incorporates the two harmoniously, resulting in a vehicle with a heavy hint of retrofuturism that many eVTOL designers yearn to achieve.

The clever details that give the DA62 this retrofuturistic appeal, such as the gull-wing doors and the curvature of the wing frame around the twin engines, are subtle, making the plane engaging to gaze at from numerous angles. Other touches, such as cubby holes for small items, aid this theme more subtly. Technically, these aren't especially futuristic, but they aid the overall feel by reinforcing the perception that the plane has been ergonomically crafted to every need.

One of the design features that Diamond Aircraft rightly boasts about has little to do with the DA62's appearance. The company put significant consideration into creating an airplane that would be easy to fly even with the loss of one of its engines. The simplified flight control panel is where this feature is most apparent. Essentially, as former Diamond Aircraft executive vice president Jeff Owen attests, many of the levers and switches that traditional twin-engine airplanes use have been replaced by automated processes. In the event of an engine failure, instead of adjusting a number of settings rapidly, all the pilot needs to do is turn off an engine master switch, and the electronic control units will work to reduce the drag. The stability that this provides ensures that the pilot is able to turn in the direction of the dead engine without worrying about the live engine rolling the aircraft.

Similarly, the start-up process has been simplified. Jarred Curtis, one of Diamond Aircraft's test pilots, has described it as being as simple as starting up a car. Those who don't

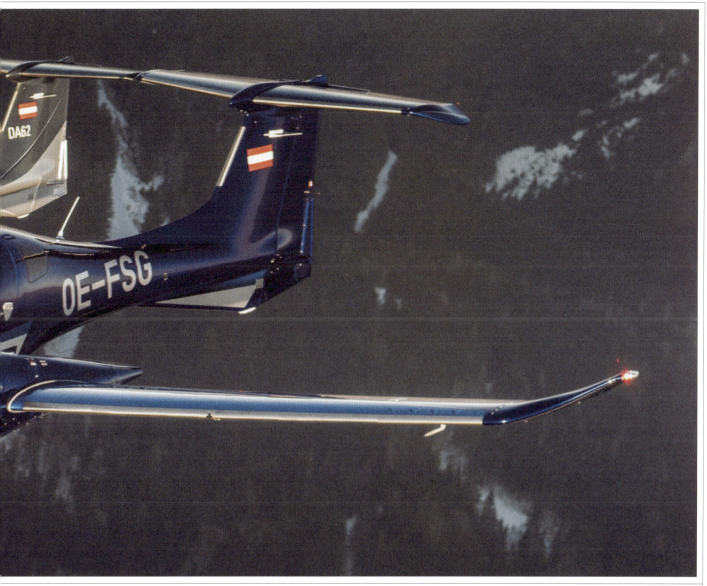
Diamond Aircraft

incl. climb, no reserves: 1,288 Nm (2,385 km)
Fuel consumption at 60% (12,000 ft) in total: 11.8 gal/h (44.7 l/h)
Dimensions: 47 ft 9 in x 30 ft 2 in x 9 ft 3 in (14.55 m x 9.19 m x 2.82 m)
Seats: Seven
Empty weight: 3,523 lbs (1,598 kg)
Max take off mass: 5,071 lbs (702 kg)

fly aircraft for a living may find themselves disagreeing, but this statement demonstrates how the company's engineers have worked tirelessly to design a product that is at the forefront of user-friendliness in the aviation industry.

The cabin and the fuel system utilize other invisible design features to boost safety. Trevor Mustard, a Diamond Aircraft sales manager, has explained that this cabin is surrounded by a 26g safety cell, which was included with the thought process of making something as durable as a modern-day Formula One race car that can protect occupants in the event of a 200-mile-per-hour crash. A dual-wing spar protects the fuel cell running through the center of the wing. The company could have certified the vehicle with just a single wing spar, yet it wanted to provide an additional layer of protection.

All of this information proves two facts regarding the DA62: It looks outstanding, and it's been designed with the highest safety standards in mind.

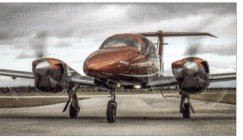

SO THE TRADITIONAL TWINS, WHEN YOU LOST AN ENGINE, IT WAS A BIG EMERGENCY. AND THAT'S CERTAINLY NOT THE CASE WITH OUR TWIN. THE DESIGN OF OUR TWIN, WHEN YOU LOSE AN ENGINE, IT'S REALLY A NON EVENT.

Scott McFadzean, *Former CEO, Diamond Aircraft*

TAURUS ELECTRO BY PIPISTREL $151K

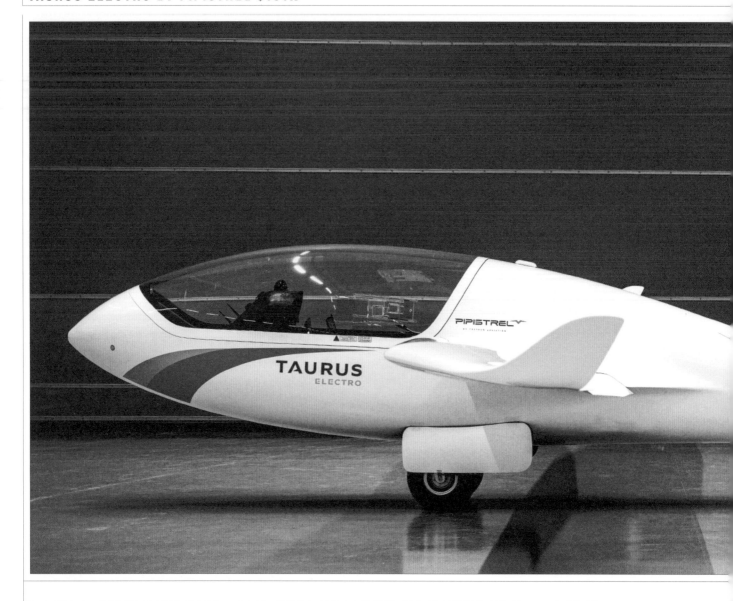

Engine: Taurus Electro Electric 40/30
Max power: 35 kW 1 min/30 const
Propeller - two blade: Pipistrel GVTE prop
DIMENSIONS:
Wing span: 49 ft (14.97 m)
Length: 24 ft (7.30 m)
Height - propeller extended: 8 ft, 9 in (2.7 m)
Rudder area: 9 square ft, 7 square in (0.9 m²)

The Taurus Electro's teardrop-shaped fuselage is certainly impressive. Yes, many other glider manufacturers opt for teardrop designs, but Pipistrel, the company behind the Taurus Electro, appears to have stretched this shape as far as possible. This streamlined configuration can leave no one in doubt of the aircraft's aerodynamic superiority.

Contrast the Taurus Electro with the other plane in this issue, the DA62. In some ways, they are two sides of the same coin in terms of crafting a modern-looking vehicle. Both seem to have a space-age influence. While the DA62 looks like the vehicle that futurists would envisage based on the proportions of 1950s rockets, the Taurus Electro seems to take the concept of a 1980s shuttle to its most extreme possible conclusion. Or, to put it in a more philosophical manner, one reflects the idealism of the earliest days of spacefaring, and the other amplifies the innovations of the start of the era of long-term space occupancy.

Much like how the reusability of the shuttle innovated space travel, the Taurus Electro has provided some interesting innovations for the aviation industry. The fact that it is the first electric two-seat aircraft to enter production is impressive. Yet this only scratches the surface of how it has moved aviation in a bold new direction.

Consider the accumulated cost savings, which many will certainly consider to be an even more impressive design achievement. Pipistrel made the affordability of the Taurus Electro a long-term consideration. Thanks to the glider's solar trailer and self-launching capability, there are no regular power cost considerations with the glider's usage. Instead, the solar trailer charges the vehicle in as short a timeframe as five hours with no need to be connected to a power source other than the sun. Basically, if society were to collapse, then the Taurus Electro could feasibly continue running for many years. This power source also makes the glider emission-free. Other advantages that come with the vehicle's electric system include the fact that it can use a shorter runway, climb faster, and perform stronger at high altitudes.

Perhaps the greatest design achievement of the Taurus Electro is the battery management system. Pipistrel's engineers created an in-house solution that had, in Pipistel's own words, "tighter tolerances than commercially available systems," resulting in superior performance and battery life. When a battery cell begins malfunctioning, the battery management system also alerts the pilot, ensuring that unexpected losses of power will not be a catastrophic issue. During flight,

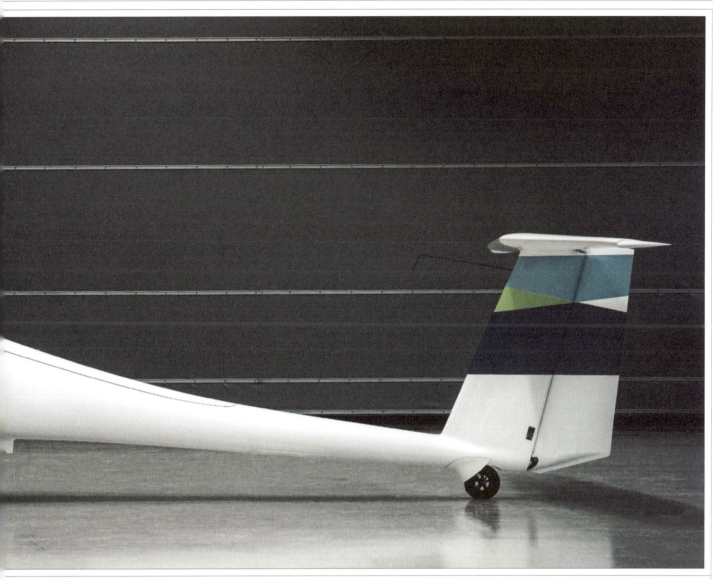

Pipistrel

Horizontal tail area: 14 square ft, 6 square in (1,3 m²)	**Aspect ratio:** 18.6 **Empty weight:** 370kg including batteries	**Max take off weight:** 1,213 lbs (550 kg) **Maneuevering speed:** 152 km/h (82Kts)	**Max speed with airbrakes out:** 152km/h (82 Kts)

the battery management system controls battery cell temperature, with the cooling system optimizing performance. A further feature that protects these batteries is the power inverter/motor controller. As the name implies, these also protect and aid the performance of the motor.

With a price tag of around $151,000, the Taurus Electro also makes it easy to imagine just how prevalent air travel will become in the following decades. Of course, for most, that is a significant sum of money. However, the truth is that it is now possible to take to the skies, with zero fuel costs, for one-third of the average price of an American home in 2023. Future innovations will surely bring costs down significantly, allowing greater numbers of people to afford aircraft. In that sense, the Taurus Electro could well be remembered as the plane that ushered many more people to the skies, in much the same way as how the shuttle brought significantly more people to space than ever before.

PIPISTREL IS PRESENTING ANOTHER WORLD'S FIRST—THE CONCEPT OF FLYING FOR FREE.

A

ARCHITECTURE & EXHIBITS

122 AZABUDAI HILLS BY MORI BUILDING CO. & HEATHERWICK STUDIO / JAPAN & UK

124 WEEBARNHOUSE BY ALCHEMY ARCHITECTS / USA

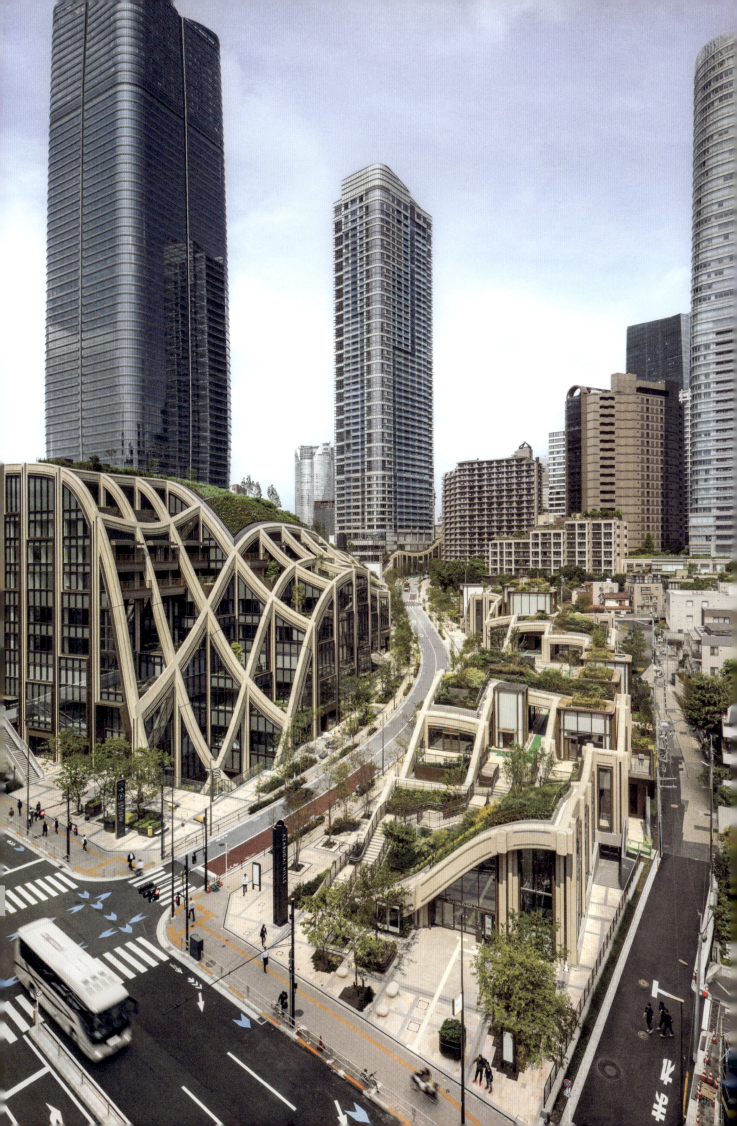

AZABUDAI HILLS BY MORI BUILDING CO. & HEATHERWICK STUDIO $4.24B

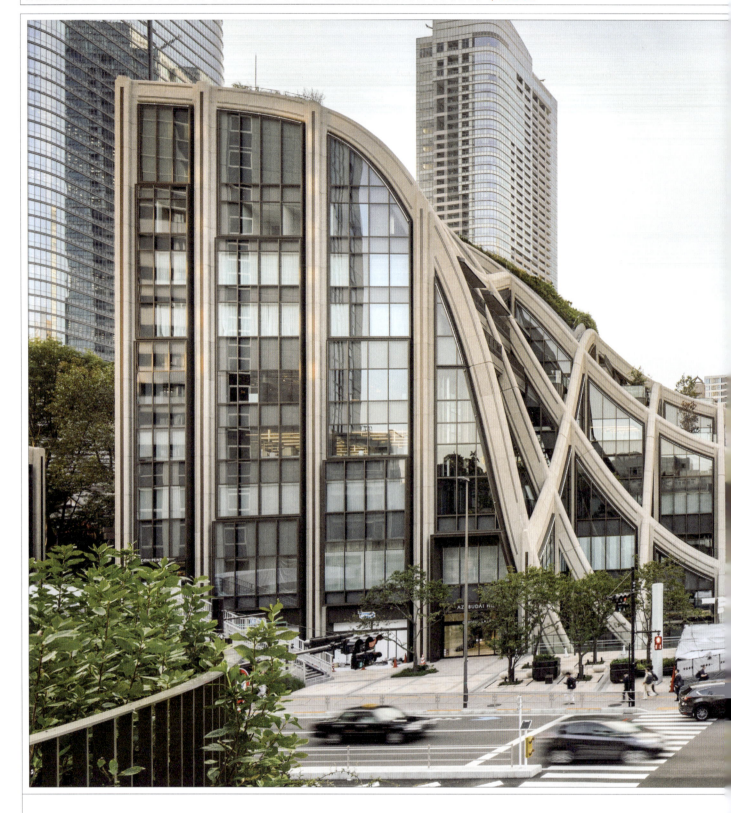

In late 2023, the opening of Azabudai Hills in Tokyo was such an occasion that the former prime minister of Japan himself, Yoshihide Suga, led the event. The fact that the one-time head of the world's third-largest economy presided over this occasion speaks volumes of the district's ambition and visual grandeur.

Azabudai Hills describes itself as a modern urban village brimming with nature. This description may be accurate, yet it sells short so many of its impressive features. Yes, it is true that every street in this neighborhood is filled with nature, but some utterly outstanding structures are also located around this greenery.

Certainly, when viewed from above, the trees, plants, and grasses that cover Azabudai Hills stand in stark contrast to the surrounding grey and silver cityscape. When viewed from within the neighborhood, however, the many striking design elements created by Heatherwick Studio and Mori Building Co. stand out. Overall, the exterior has a cohesive curving design, with its two most prominent structures, Garden Plaza A and Garden Plaza B, being the perfect examples. These two buildings appear to sag in the same manner as the clocks in Salvador Dalí's *Persistence of Memory* painting, with the layout of Sakurama Street separating the two, suggesting that something has sliced and cauterized one construction into two. On a much smaller scale but no less impressive is The Cloud, a canopy located within the arena section of the neighborhood's central square. This canopy certainly resembles a cloud. Yet it also calls to mind MC Escher's spiral-themed works through its track-like circular elements.

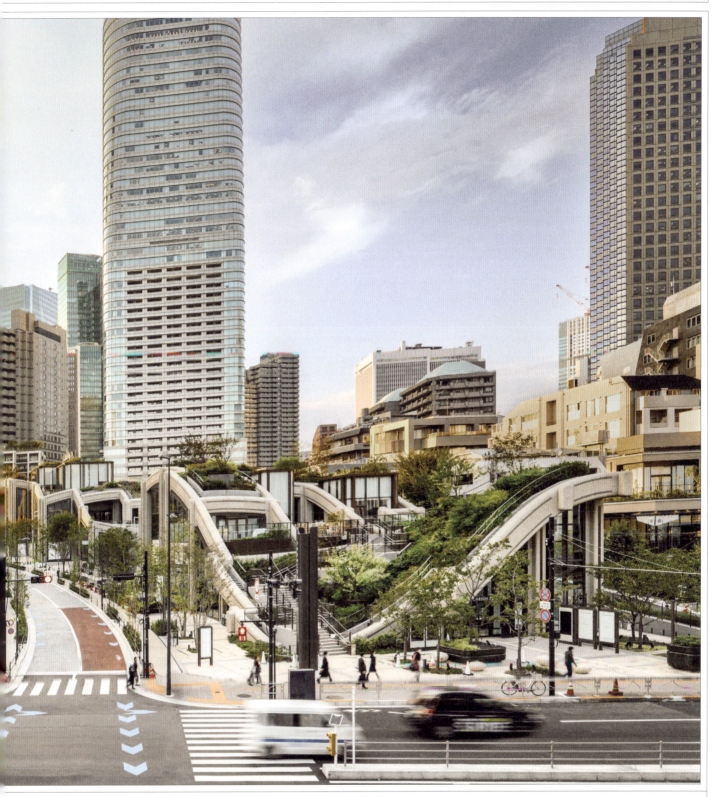

Photo: Raquel Diniz

Part of the joy of seeing Azabudai Hills at the very start of its completion is witnessing the buildings within this neighborhood spring to life. In March 2024, the market building opened its doors for the first time, welcoming visitors through an entryway framed with a shell-like roof reminiscent of the Sydney Opera House. Inside, 34 stores offering a range of food, drink, and even flowers opened for business, situated around ridged walls that seamlessly curve to form large pillars that appear to be modern reinterpretations of Roman columns.

The intricacies of Azabudai Hills are the culmination of over 30 years of development and regeneration. Mori Building Co., the organization that led the lengthy revitalization, collaborated with over 300 individuals and businesses in the neighborhood to ensure that the space would become something truly supportive of the community. The firm states that over 90% of the area's original tenants and businesses have remained, a testament to the successful realization of a cohesive urban design.

In sprawling cities like Tokyo, neighborhoods have a tendency to blend into one another, making it challenging to tell where one ends and the other begins. This cannot be said for Azabudai Hills, which proudly boasts uniqueness in almost every square inch of its space.

WEEBARNHOUSE BY ALCHEMY ARCHITECTS $1M

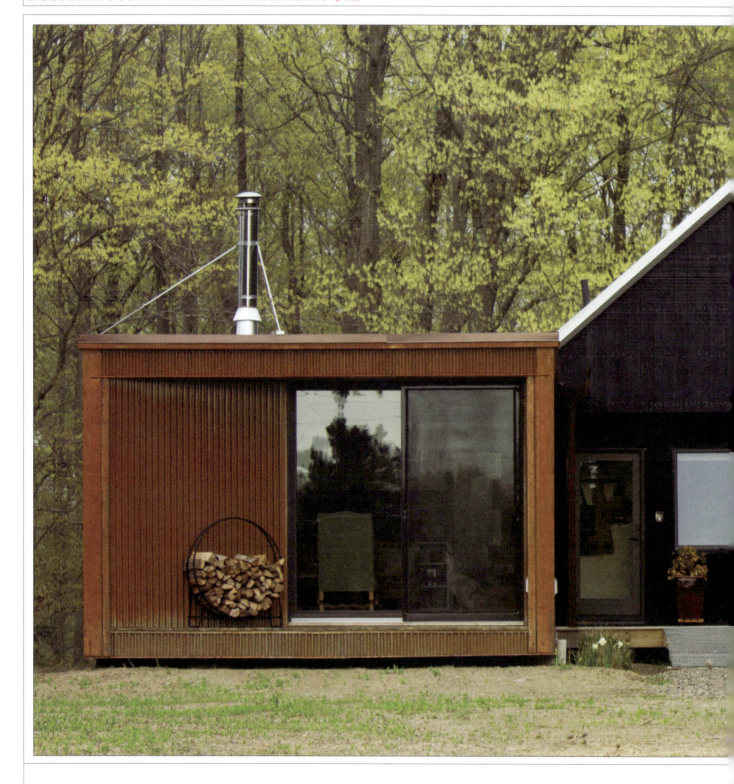

Alchemy Architects created the weebarnHouse as a modest but celebratory home located in an old horse pasture in Upstate New York. The client was a woman who was retiring from metropolitan arts administration. She was looking for an inspiring place to practice her own art, host guests, and enjoy life. The three structures that make up weebarnHouse certainly achieve this, effortlessly creating a relaxing feel and blending in perfectly with the surrounding forest. It's hard, therefore, to believe that they are actually prefabricated variants of a standardized design platform.

Alchemy has designed system-based weeHouses and barnHouses across the USA, embracing quality, sustainability, and typically smaller footprints. The 3 bedroom weebarnHouse - at only 1,350 square feet - is the first example of both design systems occurring in a single project. These are not straightforward "cookie-cutter" homes. The architects work to cater each project to client needs and area constraints, ensuring that no two constructions are exactly the same. The customized designs are then realized as modular prefabs, panelized prefabs, or on-site construction projects. The weeBarnHouse project utilized a mix of both modular and panelized prefabrication.

The simple agrarian typologies of the structures use urban logic to create a new context in the woods. The weeHouse is made of oxidized corrugated steel, which, with its brown color, gives the impression that it is a transitional gateway from the woodland into a comfortable home. A custom oversized gut-

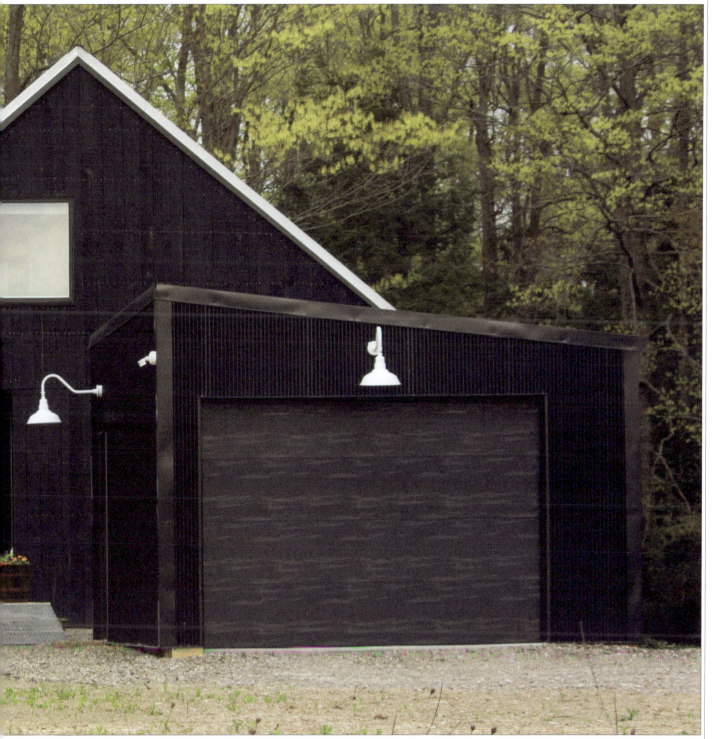

Alchemy Architects

ter-awing protects large south-facing glass doors, allowing sunlight to illuminate a sizable combined living room, dining room, and kitchen. A box containing a bathroom and pantry separates this space, with a bedroom beyond.

At the junction between the weeHouse and barnHouse, a recess creates a covered entry leading to a laundry-work-storage space and a studio-bedroom area. The sleeping loft above is accessed by an industrial alternating tread stair. This barnHouse is clad with a black painted barn board rain screen made of randomized rough-sawn pine. The shed contains a simple single-car garage and a small workspace. It is made of black corrugated steel, unifying the material and color of the other two buildings.

Alchemy also took a novel yet budget-conscious approach to furnishing the kitchen and bedroom areas. They decided to customize a range of IKEA furniture into the design, such as by placing three small bookcases alongside one another to act as a single back leg for a kitchen counter at the point where the large weeHouse room transitions from kitchen to dining area. This step has made a low-cost item look like an impeccably crafted piece of carpentry.

This building project, by customizing prefabricated structures and adapting affordable furniture, utilized a range of clever money-saving measures without compromising on quality. In today's ever-budget-conscious world, we all could use this as inspiration to get creative when financial constraints become an issue!

EDUCATION

128 DOUGLAS MAY (UNIVERSITY OF NORTH TEXAS

Douglas May (University of North Texas):
Being Consistently Creative

DOUG IS A CORNERSTONE OF OUR DESIGN COMMUNITY AND IS REGARDED AS A STEWARD AMONG INDUSTRY PROFESSIONALS, CLIENTS, ASPIRING STUDENTS, AND DESIGN EDUCATORS.

Whitney Holden, *Lecturer, University of North Texas*

DOUG CREATES A SPACE FOR STUDENTS TO FIND WAYS OF THINKING TO DESIGN WITH INTENTION AND PURPOSE AND PROVOKES STUDENTS TO LOOK CLOSELY AT CULTURE AND THEIR ENVIRONMENTS.

Hyejung Ko, *Former Student & Product Designer, TikTok*

A DESIGN MASTER AND A GURU, DOUG MAY GENEROUSLY INVESTS IN EACH STUDENT, HELPING THEM ACHIEVE THEIR FULL POTENTIAL AND LIFELONG FULFILLMENT IN DESIGN.

Stephen Zhang, *Assistant Professor, University of North Texas*

DOUG DEFTLY BALANCES FIERCE ADVOCACY FOR STUDENTS WITH GENEROSITY IN SHARING KNOWLEDGE. HIS EXTENSIVE EXPERIENCE AND KINDNESS, NOT TO MENTION HIS HUMOR, MAKE HIM AN IMITABLE FIGURE IN OUR COMMUNITY.

Erica Holeman, *Assistant Professor, University of North Texas*

DOUG MAY REPRESENTS THE RARE COMBINATION OF BALANCED LEFT AND RIGHT BRAINS. HE IS COMPARABLY EXCELLENT AS A BUSINESS PERSON, PROBLEM SOLVER, GROUP LEADER, COMMUNICATOR, AND DESIGNER.

Joseph Feigenbaum, *Senior Marketing Strategist, Annexus Group*

Polish Jazz! Yes!, Poster Annual 2023. Designer: Douglas May. Design Firm: May & Co. Client: RadioJAZZ.FM. Award: Gold

(Page 127) Tarot Sanguine, New Talent Annual 2022. Professor: Douglas May. Gold-winning student: Andrea Garoutte
(Above) America: 2016-2020, Protest Posters 2. Designer: Douglas May. Self-initiated. Award: Gold

Jeju Evening. Design Annual 2024. Designer: Douglas May. Client: Communication Design Association of Korea. Award: Gold

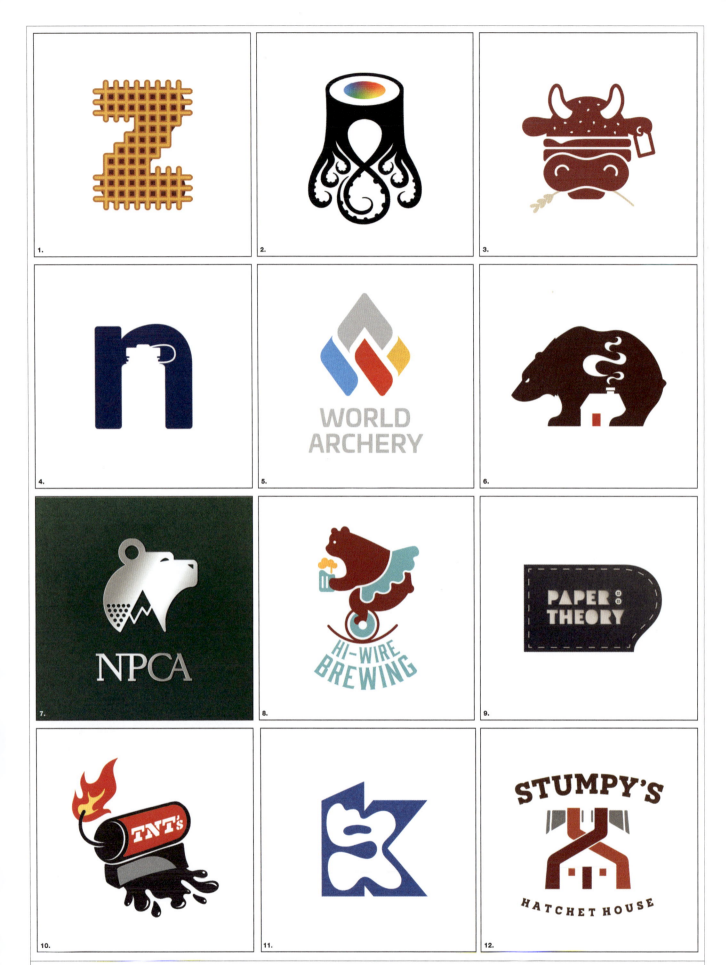

1. *Zinneken's Gourmet Waffles, New Talent Annual 2021. Professor: Douglas May. Gold-winning student: Anna Long* / 2. *8 Arm Sushi, New Talent Annual 2023. Professor: Douglas May. Platinum-winning student: Lauren Clark* / 3. *Farm Burger Logo, New Talent Annual 2022. Professor: Douglas May. Silver-winning student: Aubrey Barnes* 4. *Nalgene Logo, New Talent Annual 2024. Professor: Douglas May. Gold-winning student: Macy McClish* / 5. *World Archery, New Talent Annual 2024. Professor: Douglas May. Gold-winning student: Jalon Isabell* / 6. *Bear's Smokehouse and BBQ, New Talent Annual 2024. Professor: Douglas May. Gold-winning student: Rachel Blow* 7. *National Parks Conservation Association, New Talent Annual 2023. Professor: Douglas May. Gold-winning student: Adriana Vieraitis* / 8. *Hi Wire Brewing Logo, New Talent Annual 2024. Professor: Douglas May. Gold-winning student: Felicia Tshimanga* / 9. *Paper Theory Logo, New Talent Annual 2021. Professor: Douglas May. Gold-winning student: Hana Snell* 10. *TNT's Custom Screen Printing Logo Redesign, New Talent 2024. Professor: Douglas May. Gold-winning student: Macy Belton* / 11. *Kunsthaus Graz, New Talent Annual 2021. Professor: Douglas May. Silver-winning student: Javier Ruiz* / 12. *Stumpy's Hatchet House, New Talent 2024. Professor: Douglas May. Silver winning student. Jazmine Garcia*

Introduction by **Ashley Owen** *Former Student & UX Designer, PwC*

As a professor, Douglas May embodies exceptional design education through his inspiration and mentorship. His unwavering commitment to fostering creativity encourages students to think beyond conventions, and his enthusiasm is contagious. His lectures motivate students to explore ideas and not be afraid to fail. Whether it's brainstorming ad campaigns or art direction, he instills a love for innovative and iterative thinking, and his unwavering belief in student potential fuels their determination to keep experimenting and growing. Ultimately, his professional guidance enables students to discover the art of pushing boundaries, embracing resilience, and perpetually seeking growth.

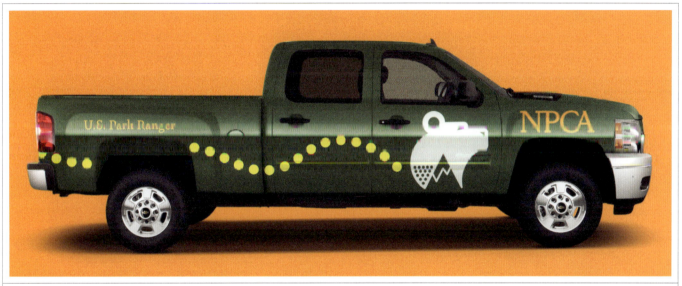

National Parks Conservation Association, New Talent Annual 2023. Professor: Douglas May. Gold-winning student: Adriana Vieraitis.

Q&A: Douglas May, Professor, University of North Texas

What attracted you to teaching at your current school?
After running my design firm, May&Co., for 30 years, and before retirement, I wanted to share my professional experiences with the next generation of designers. Over the years, I have seen many talented designers grow frustrated with the business. I seek to teach not only the aesthetic skills required for the job but also an understanding of how to manage the development of new ideas so that concepts aren't easily killed by risk-averse thinking.

What is your department's process for selecting students for your program? Are there specific qualifications they must meet?
At the University of North Texas, where I teach, we have a purpose-built curriculum that provides a rigorous communication design education. Our freshmen must take the College of Visual Arts and Design's art foundation curriculum, which introduces visual problem-solving and critical-thinking strategies by incorporating and studying culture, history, and practices of various art and design forms across disciplines.

Admission to our graphic design track is a two-part process. At the end of the fall semester, there is a candidacy review to admit approximately 60 freshmen into the first of our ComDes courses. This review is based on a six to ten piece portfolio submission and a design-thinking worksheet exercise. This work is reviewed and scored by the entire Communication Design faculty. At the end of the freshman spring semester and the first ComDes course, there is the second portfolio review to admit about 66% of those students fully into the graphic design track of the Communication Design Program. Projects from this course are reviewed and ranked, and the 40 who rank the highest are officially accepted into the program.

Is there anything that would make you turn down a prospective student?
We're looking for imaginative and curious students who we believe are capable of intellectually maturing. Students whose artistic skills are weak or undeveloped are at a disadvantage. Most importantly, students who don't demonstrate that they're willing or able to engage in conceptual development and critical thinking will most likely not be selected for our program.

Have you ever dismissed a student from your class?
A few times, I have called out individual students for plagiarizing others' work. This usually results in an embarrassing moment for the student. I offer them the opportunity to redo the assignment to increase their chances of passing with a reduced grade. Unfortunately, I've had a situation where one student was a habitual offender and was asked to leave the program after a formal administrative review. Our faculty has embraced a "no miracles" policy, meaning if a student doesn't present iterative prelims, there is a likelihood that their effort is plagiarized. Students also need to understand that these days, it is easy for instructors to check for plagiarism through advanced image search technologies.

What might be a typical first assignment?
Design fundamentals, such as form, color, typography, and composition, are revisited often. As students successfully demonstrate a command of those skills, they are challenged to interpret their aesthetic understanding into purpose-driven visual communication. These may include posters, icon systems, book covers, portraits, spot illustrations, etc.

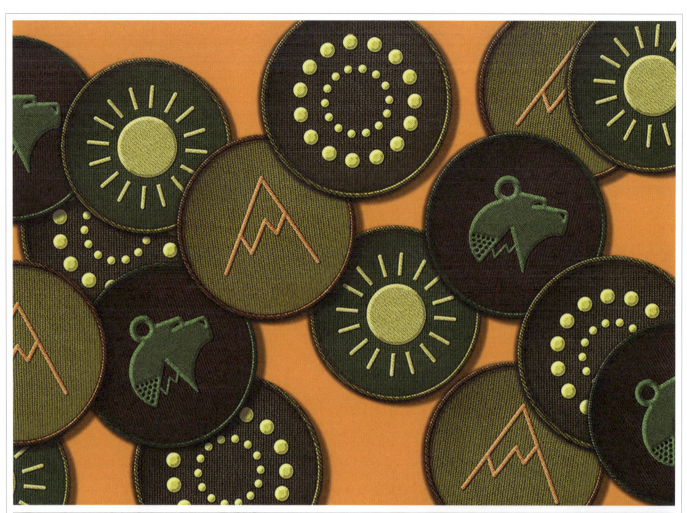
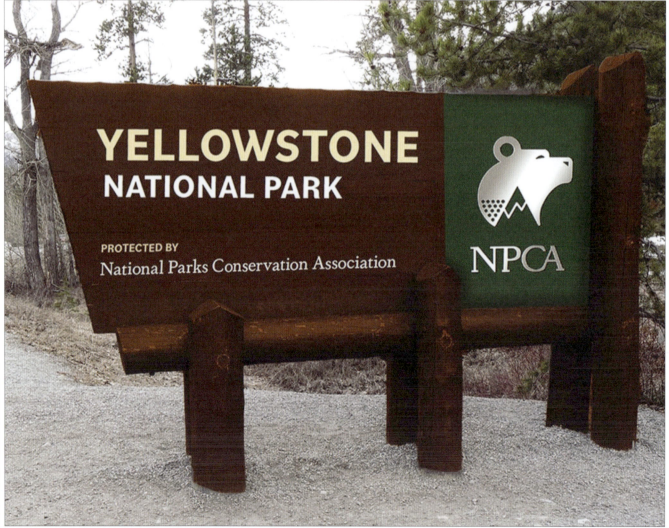

National Parks Conservation Association, New Talent Annual 2023. Professor: Douglas May. Gold-winning student: Adriana Vieraitis

Q&A: Douglas May, Professor, University of North Texas

Do you ever have students work on assignments for real clients?
Yes, we recently collaborated with the UNT Opera Department on performance posters and social media marketing for a public touring company's performance of *Carmen*. We are currently working on an extensive community mural project for a new retail center in Frisco, Texas, one of the fastest-growing cities in the US and home to UNT's North Dallas campus.

Do you ever ask students to include something they're passionate about in their work for your class?
Yes, quite often. In upper-level classes, there are opportunities for students to self-direct topics of interest. These may include choosing to design for major brands, entrepreneurial projects, social causes, or cultural events. Our faculty advises students to avoid redundant project themes to gain a broad range of experience. After a student presents their initial research, it is not uncommon for a professor to challenge students to step out of their comfort zone by reframing hypothetical product or service enhancements. Examples of this would be envisioning Sea World Sanctuary, a theoretical aquatic reserve for retired performing killer whales. Another was the creation of a birthday party kit for children identifying as non-binary. Recently, I approved a student's request to visualize a brewery that would specialize in cannabis-infused beers. Call it brand development, product design, service design, or whatever appropriate term, students must understand the critical role design offers in forecasting such horizon opportunities.

Do you work with students individually or in groups?
I work both ways. I work one-on-one for several class sessions, followed by an all-hands-on-deck class critique. Group critiques are critical for several reasons. For instance, when cohorts point out the same concerns as their instructors, peer criticism resonates strongly. I should add that I am open to students challenging my input, and occasionally, they prove me wrong, especially on emerging youth culture trends and the current interpretations of language, symbols, metaphors, and memes. The students keep me on my toes, and I welcome that dialog. At the end of each semester in my upper-level classes, I invite local design professionals to final [critiques] for an outside opinion. These sessions are always eye-opening for students. This reinforces how to present the work and articulate the process and aesthetic choices they made to achieve specific goals.

How do you develop and raise your students' visual and verbal standards?
So, that's the challenge. As I previously mentioned, high standards are introduced early in our art foundation curriculum. Besides classroom lectures, field trips, online presentations, competitions, and annual student conferences, the College of Visual Arts and Design offers several study-abroad opportunities each semester. We also have our Design Resource Room, which features an up-to-date design library. Additionally, we have a very active UNT AIGA Student Group that meets several times a month with a student-led agenda. We do promote a highly competitive environment. For students to excel, they must bring a strong and intrinsic curiosity and work ethic with them. In my classes, I quickly emphasize that with design, there's not one correct answer. This is counterintuitive to young minds that have been prepared for standardized testing in K-12 education. Many students are looking for formulas for creativity. I emphasize learning the skill of transferring pluralistic wonderment into utility.

What percentage of a typical class goes on to create award-winning work?
With every cohort, there are always several naturally bright and gifted students. Beyond that, there is a contingent of students who improve incrementally throughout their college education. I take pride when the late bloomers win awards in Graphis New Talent or other student competitions. Maturity, trial and error, and addressing challenges in a competitive environment play a significant role in building students' confidence to compete professionally.

At the end of the semester, what kind of advice do you give to the class?
I tell graduating seniors that if they don't get their dream job in New York, they can make a difference wherever they land, especially in small shops where they can influence every aspect of a project and collaborate in smaller, intimate teams. Having said that, I am proud of the students who not only land their dream job but have excelled in leadership positions in their careers.

Can you name a few of your program's graduates who have gained success? If so, what are they doing now?
Most recently, these include individuals such as Michael Ryan Wood, designer, Play SF; Gabriela Pesqueira, associate art director, *The Atlantic*; Hyejung Ko, product designer, TikTok; Nathan Profit, senior systems designer, American Airlines; Ashley Owen, UX designer, PwC; Brad Anthe, junior art director, Loloi Rugs; Kristina Armitage, visual designer, *Quanta Magazine*; Hana Snell, designer, Caliber Creative; and Javier Ruiz, designer, Tractorbeam.

Graduates from UNT's Communication Design Program have long earned jobs at respected design firms, ad agencies, and in-house design studios throughout the country. Companies that have hired our students over the years include VSA Partners, Pentagram Design, BMW, IDEO, Nike Design, Pepsi, HKS, Neiman Marcus, Starbucks Global Creative, TRG, BBDO New York, Fossil, Turner Duckworth, TBWA\Chiat\Day, Crispen Porter, and Louise Fili, Ltd.

We are equally proud of UNT design alumni who choose to remain in Texas to lead nationally respected studios such as Dennard Lacey and Associates, Chad Michael Studio, Caliber Creative, Tractorbeam, Matchbox Studio, and Banowetz + Company, among many others.

Of course, I share this success with a very engaged design faculty, administrators, and adjunct instructors, including professors David Wolske, Stephen Zhang, Erica Holeman, Whitney Holden, and recently retired Karen Dorff, led by associate dean Eric Ligon and design chair Hepi Wachter.

What do you think of the way so many people in the creative fields now are without any formal, never mind university-level, training?
I tell students that anyone can hit the creative bullseye once. A novice is just as likely to create a winning solution as a senior designer. The real challenge is, can one be consistently creative, evolve with the times, and innovate to sustain a lifelong career? This is exponentially more difficult. I am fortunate to have both university and art college experiences. Both offer profound educational advantages. However, I have witnessed that four-year academic degrees better prepare designers to interact with clients horizontally across the spectrum of businesses.

Douglas May, University of North Texas douglasmay.com

Topo Chico Campaign, New Talent Annual 2024. Professor: Douglas May. Silver-winning student: John Paul Nguyen

Under Armour HOVR Sonic Shoes, New Talent Annual 2024. Professor: Douglas May. Silver-winning student: Jordan Heath

Tarot Sanguine, New Talent Annual 2022. Professor: Douglas May. Gold-winning student: Andrea Garoutte

Graphis Books

POSTER

DESIGN

ADVERTISING

PHOTOGRAPHY

NUDES

TYPOGRAPHY

PROTEST POSTERS

New Talent Annual 2024

2024
Hardcover: 256 pages
200-plus color illustrations
Trim: 8.5 x 11.75"
ISBN: 978-1-954632-29-5
US $75

Awards: Graphis presents 13 Platinum, 132 Gold, and 587 Silver awards, along with 858 Honorable Mentions.
Winning Entrants: Design: Peter Bergman, Justin Colt, Rob Clayton, Natasha Jen, Simon Johnston, Billy Magbua, William Meek, Richard Mehl, Nathan Savage, Stephen Serrato, Hyojun Shim, Ming Tai, and David Tillinghast.
Judges: David Bernstein, Scott Bucher, Hoon-Dong Chung, Patti Judd, Jim Ma, Kah Poon, Frank P. Wartenberger, Lisa Winstanley, and others listed in the book.
Contents: This book contains award-winning entries in Advertising, Design, Photography, and Film/Video. There are full-page images of Platinum-winning work from talented teachers and students. Gold and Silver-winning work is also presented, and Honorable Mentions are listed. We also present A Decade of New Talent, featuring Platinum-winning works from 2014.

Photography Annual 2024

2024
Hardcover: 256 pages
200-plus color illustrations
Trim: 8.5 x 11.75"
ISBN: 978-1-954632-28-8
US $75

Awards: Graphis presents 12 Platinum, 102 Gold, and 216 Silver awards, along with 54 Honorable Mentions.
Winning Entrants: Craig Cutler, Lindsey Drennan, Jonathan Knowles, James Minchin, Artem Nazarov, Peter Samuels, Howard Schatz, John Surace, and Paco Macias Velasco.
Judges: Per Breiehagen, Nick Hall, Takahiro Igarashi, RJ Muna, and Hadley Stambaugh.
Content: This book is full of exceptional work by our masterful judges, our Platinum, Gold, and Silver award winners, and our Honorable Mentions. It also includes a retrospective on our Platinum 2014 Photography winners, a list of international photography museums and galleries, and an In Memoriam list of photographers who have passed away this past year. The digital copy has an extra 52 pages of additional content for you to peruse.

Advertising Annual 2024

2024
Hardcover: 224 pages
200-plus color illustrations
Trim: 8.5 x 11.75"
ISBN: 978-1-954632-25-7
US $75

Awards: Graphis presents 16 Platinum, 61 Gold, and 99 Silver awards, along with 14 Honorable Mentions.
Winning Entrants: ARSONAL, Brunner, Célie Cadieux, Extra Credit Projects, Freaner Creative & Design, PangHao Art Studio, Partners + Napier, PETROL Advertising, ReThink, Rhubarb, SJI Associates, Sukle Advertising, and SUPERFY.
Judges: Ariel Freaner, Alan Hunter, Suzy Jurist, Ben Nessan, Andrea Por, and Christina Roche.
Content: This Annual includes amazing Platinum, Gold, and Silver Award-winning print and video advertisements from well-established firms and agencies. Honorable Mentions are also presented. Also featured in the annual is a selection of award-winning work from the competition judges and our yearly In Memoriam list of the advertising talent we've lost over the last year.

Design Annual 2024

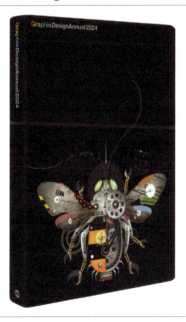

2023
Hardcover: 272 pages
200-plus color illustrations
Trim: 8.5 x 11.75"
ISBN: 978-1-954632-24-0
US $75

Awards: Graphis gave 12 Platinum, 108 Gold, and 436 Silver awards, along with 182 Honorable Mentions, to many international designers who challenged what design can do with innovative, creative works.
Winning Entrants: AV Print, The Balbusso Twins, Carmit Design Studio, Journey Group, Michael Pantuso Design, Namseoul University, Omdesign, PepsiCo Design & Innovation, Studio Eduardo Aires, Sun Design Production, Underline Studio, and Wonderlust Industries, Inc.
Judges: Antonio Alcalá, Roger Archbold, Maria Alma Guede, Mike Hughes, Byoung il Sun, and Vishal Vora.
Content: This book includes award-winning work from the judges, as well as Platinum, Gold, and Silver-winning work from internationally renowned designers and design firms. Honorable Mentions are presented, and a list of designers that we have lost this past year and a directory of design museums are also included.

Poster Annual 2024

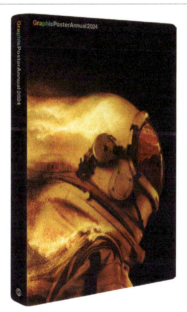

2023
Hardcover: 256 pages
200-plus color illustrations
Trim: 8.5 x 11.75"
ISBN: 978-1-954632-23-3
US $75

Awards: Graphis gave 14 Platinum, 100 Gold, and 266 Silver awards, along with 211 Honorable Mentions, to many international poster designers who challenged what poster design can be with innovative, creative works.
Platinum Winners: Antonio Castro Design, Atelier Radovan Jenko, Chemi Montes, Holger Matthies, Kashlak, Kiyoung An Graphic Art Course Laboratory, Mirko Ilic Corp., MOCEAN, Peter Diamond Illustration, Šesnić&Turković, Supremat, The Refinery, and Underline Studio.
Judges: Peter Bankov, John Gravdahl, Carmit Makler Haller, Noriyuki Kasai, Viktor Koen, Mi-Jung Lee, and Marlena Buczek Smith
Content: This hardcover book displays full-page images of Platinum-winning work from talented poster designers. Gold and Silver-winning work is also presented, and Honorable Mentions are listed in the physical copy. All work is presented equally on our website.

Narrative Design: Kit Hinrichs

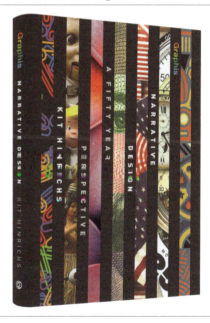

2023
Hardcover: 248 pages
200-plus color illustrations
Trim: 9 x 12"
ISBN: 978-1-954632-03-5
US $65

Narrative Design: A Fifty-Year Perspective is a collection of over 50 years of work from the obsessive graphic designer Kit Hinrichs. To the legendary AIGA medalist, author, teacher, and collector, design is the business of telling a story. It's not just about communicating a product or a corporate ethos—it's about contributing to the collective culture of storytelling. Presented in the book are not individual case studies but rather categories of work and graphic approaches to assignments that have wowed clients and dazzled viewers. The work is arranged to communicate Hinrichs' creative thinking, which always leads to a unique and effective solution to any design conundrum.

Books are available at graphis.com/publications

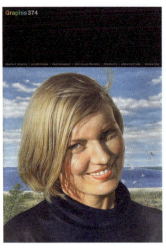

010 **Ron Taft**	010 **Studio Eduardo Aires**	010 **DJ Stout**	010 **Carmit Makler Haller**
024 **Strømme Throndsen Design**	022 **Rhubarb**	028 **Rikke Hansen**	024 **Peter Bankov**
036 **Mirko Ilic**	038 **Partners + Napier**	046 **Saatchi & Saatchi Wellness**	034 **Leroy & Rose**
050 **Ally & Gargano**	050 **Torkil Gudnason**	060 **Henry Leutwyler**	050 **DeVito/Verdi**
066 **Kah Poon**	064 **Bruce DeBoer**	076 **Nicholas Duers**	066 **Hugh Kretschmer**
080 **Rob Fiocca**	078 **Jim Norton**	092 **Jack Unruh**	080 **Trevett McCandliss**
094 **Dan Cosgrove**	090 **Mark Hess**	118 **Theron Moore**	096 **Paul Garland**
124 **Kevin O'Neill**	116 **Hank Richardson**		126 **Richard Wilde (Part 1)**
136 **Patti Judd**			

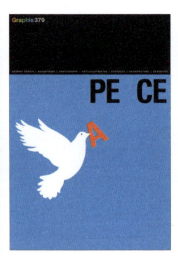

010 **PepsiCo Design & Innovation**	010 **Jones Knowles Ritchie**	010 **Armando Milani**	010 **CF Napa Brand Design**
024 **Marlena Buczek Smith**	022 **Holger Matthies**	024 **Rose Design**	026 **Kiyoung An**
038 **&Walsh**	040 **Steven Heller**	038 **John Gravdahl**	044 **Dean Stockton**
052 **Fallon**	046 **Robert Talarczyk**	054 **Greenhaus**	060 **Per Breiehagen**
068 **Michael Winokur**	062 **Takahiro Igarashi**	068 **Andreas Franke**	078 **Rafael Vasquez**
080 **Darnell McCown**	074 **Cameron Davidson**	082 **Beth Galton**	096 **Brad Holland**
094 **Balbusso Twins**	084 **Felix Holzer**	098 **Victo Ngai**	132 **Claudia Strong**
128 **Richard Wilde (Part 2)**	098 **Daren Lin**	128 **Taylor Shipton**	
	126 **Josh Ege**		

ADVISORY BOARD

QUINNTON HARRIS

PATTI JUDD

MICHAEL PANTUSO

Quinnton Harris

Retrospect co-founder and chief executive officer, Quinnton J. Harris is a creative leader and entrepreneur living in Brooklyn, New York. His new venture focuses on building products and digital experiences that are radical, culturally nuanced, and more accessible for untapped or overlooked market opportunities. Previously, he served as Publicis Sapient Group's creative director within experience design as well as co-leader of global computational design, which focused on evolving the organization's design systems practice. He played a critical role in accelerating CXO John Maeda's vision for fostering a more inclusive, multi-dimensional, and cohesive experience design capability. He also served as head of experience for San Francisco. In early 2020, he completed a short tenure as John Maeda's chief of staff, finding much success in pushing critical CXO initiatives, implementing systems for global collaboration, and enhancing internal communication strategies. Quinnton also led the #hellajuneteenth movement and got over 600 companies committed to observing Juneteenth as a paid holiday for its employees. Prior to joining Publicis Sapient, he served as inaugural creative director at Blavity, Inc., and before that led design at Walker & Company Brands, a start-up consumer products and tech company notably acquired by Procter & Gamble. He is an MIT alum, graduating with a SB in mechanical engineering and dual minors in architecture and visual arts.

Patti Judd

Award-winning creative director, accomplished marketing and film executive, and co-founder of the San Diego International Film Festival, Patti joined Graphis as chief visionary officer. A key initiative was forming the Graphis Industry Advisory Board to promote greater industry insights and connections globally. Patti blends business savvy gained from twenty plus years at her agency with the entertainment biz acumen garnered from working in music and film. Her studio, Judd Brand Media, champions her passion for creating innovative work, receiving over 100 awards in design, advertising, and marketing. Her work includes notable global brands such as WME, Disney, Mattel, Montreux Jazz Festival, Century 21, Aramark, Service America, and Hilton, alongside numerous emerging brands, recording artists, and filmmakers. Her influence goes from helping launch a major live music venue, where she was a key player in its growth, to one of the top live jazz venues in the world, to co-founding the San Diego International Film Festival. She holds two executive producer credits for a children's TV series on Nickelodeon and a feature film in association with the BBC, which premiered at Sundance (acquired by Universal Pictures). Currently, she is in development as executive producer on an exciting new animated children's series. Patti's nonprofit work includes being a foster youth board member and a past president of an arts and culture board benefiting Balboa Park, the largest urban cultural park in the US. Recently, she was awarded as an Altruist Honoree by *Modern Luxury* magazine.

Michael Pantuso

As a multidisciplined graphic designer and artist, Michael Pantuso thrives at the intersection of creative thinking, artistic expression, and strategically inspired ideas. Throughout his career, Michael has managed his own design practice, partnered with the branding agency IDEAS360°, and held positions inside TBWA Worldhealth (formerly CAHG) and Discover Financial. Located in the Chicago area, Michael is focused on creating design and art for clients, collectors, and organizations that make a social impact—these include charities, not-for-profits, NGOs, educational and arts bodies, social enterprises, and for-profit businesses who want to do more good. Michael's practice creates all the usual outputs of a branding agency—design identities, advertising, social media, print literature, websites, email, e-newsletters, photography, etc. But he does so in the context of a bigger picture—a vision for what the brand is, and, more importantly, what it can become. It's a passion that comes from a desire to make things better. Michael's art is an extension of this passion, but it's revealed and expressed in a more visceral way. One example of this can be seen in his "Mechanical Integration" work, where he explores nature and humanity through a series of fine art illustrations that integrate natural life forms with the inner workings of mechanical components. Part of this collection was recently celebrated as a solo exhibition which began in Paris, France, followed by a tour of Europe that concluded in early 2020. Much of that work now remains in galleries and private collections.